Everything You A S0-CBU-515
to Know About Curating*

Art Center College of Design
Library
1700 Lida Street
Pasadena, Calif. 91103

ART CENTER COLLEGE OF DESIGN

3 3220 00291 5291

*But Were Afraid to Ask

Everything You Always Wanted to Know About Curating*

Hans Ulrich Obrist

708.00922
013e
2011
c.2

Art Center College of Design
Library
1700 Lida Street
Pasadena, Calif. 91103

***But Were Afraid to Ask**

Sternberg Press

Table of Contents

Legend

~~Strikeouts~~ Of the gyring spiral of phrases that pick
 up new meaning along the way...

<u>Underlined</u> Passages selected by the editor

❖ See ...*dontstopdontstopdontstopdontstop*
 (New York and Berlin: Sternberg Press, 2006).

Interviewer into an Interviewee

Hans Ulrich Obrist always has the question mark handy. He never leaves home without it. Yet the question mark is but one of the many tools in his toolbox. In this book, the tables have been turned, the question mark has been put into the hands of others: the interviewer Hans Ulrich Obrist becomes the interviewee. This selection puts the curator *par excellence* under the scrutiny of a novelist, an architect, fellow curators and collaborators, journalists a plenty, and a young student who took him along for a two-hour taxi drive, proving that the linguistic phrase "once said" is but a lie.

"[Christian] Boltanski pointed out to me that the danger of interviews is that we always say the same thing." We've marked these spots accordingly, with either "❖ ... *dontstopdontstopdontstopdontstop*" (the predecessor to this volume) or strikeouts. The point is not to eliminate repetition, but rather to call attention to the thrust of Obrist's documented work: like a gyring spiral of phrases that pick up new meaning within the ever-changing context. The interviews themselves often deal with the notion of amnesia and of "missing history," hence this book takes a journey into the as yet unmapped universe of exhibition history, with Obrist in the passenger seat, scanning channels on the radio.

In other words, this volume offers up some of the key notes of what it means to be a quixotic spark plug of a curator in the footsteps of Harald Szeemann, Pontus Hultén, and Alexander Dorner; what it means to wish that the "art world would stop flying"; what it means to have elected "routine as the enemy." This is a handbook for anyone who wishes to know what it means to be the curator Obrist, and who was never afraid to ask, ever.

April Lamm
Berlin, December 2007

Art Center College of Design
Library
1700 Lida Street
Pasadena, Calif. 91103

There are many things to say about Hans Ulrich Obrist, not only because he notoriously does many things (and famously insists on sleeping very little), but rather *how* he does them is equally far from usual. There is a joyful *rapprochement* of art and life in the incessant flow of activity he tends to generate, which often results in the construction of everyday situations which are as artificial and strange as they are efficient and goal-oriented. To get a sense of this, I recommend reading the interview with Ingo Niermann first, as he made the effort to describe some of the situational goings-on of the conversation printed here. From the moment I first encountered Obrist when he interviewed me in a café in Frankfurt in 2002, I was always very interested in his quasi-situationist mode of being. Much of this is generated by kind of poetic insertions into everyday interaction, like screaming "Valerio!" out of the blue (in the 1990s), adding the word "ever" regularly (e.g. ever foreword ever), repeating sentences twice (borrowed from Dürrenmatt), or via rules that are harder to detect, such as never or very rarely formulating negative sentences (I've heard one once or twice in the last seven years) and many, many more. Obrist obviously adheres to most existing conventions of interaction, but then there are others like those mentioned here which he has somehow invented and that people just have to live with or learn to understand. He is thus someone who actively seeks to mold his subjectivity, and in my view, thereby exemplifies what contemporary "technologies of the self" might look like. This alone is of considerable interest; nonetheless, there is also relevant content and positioning transported within this attitude.

In an era that is based on specialization and specialists, Obrist is probably one of the few who come close to being something of a generalist. He can speak with or interview just about anyone from any field without seeming like a novice to the context and can probably elicit more from his subject than a more specialized interviewer.

9

His own (professional) specialty, however, is to set up structures—he would say "machines"—which continue to have a life of their own. The metaphor of an exhibition (or any format that he has initiated, like the 24-hour interview marathon) as an organic, self-evolving entity is one motif that recurs in the different interviews of this book. As he repeatedly states, his project aspires to be a "complex dynamic system with feedback loops," which implies that a certain giving up of control is wished for, and failures are simply a vital feature of a "learning system." In this sense, Obrist is first and foremost an initiator, somebody who starts things in varying fields (mainly art and architecture) and domains (mainly exhibitions and interviews), and then hopes for them to generate their own dynamics.

Rem Koolhaas once said that there are very few positions nowadays as those of curators like Obrist, whose decisions about the validity of something are made instantly and irrevocably. Yet Obrist's self-organizing structures are also a way to insert moments and modalities of nonexclusivity or less exclusivity (and depersonalization, one might add) into a profession which is based on distinctions and, therefore necessarily, exclusions. In this respect, it is quite telling how he speaks with Noah Horowitz about his exhibition of instructions, "do it," and its way of functioning, which could largely be extended to his entire operation: "Rather, ['do it'] was algorithmic, an 'open score' that just popped up wherever interest surfaced, like in Bangkok [1997] when this energetic group of young artists appropriated the theme and profoundly redirected it. Some of the issues this project raised, such as access, transmission, mutation, infiltration, circulation, have cycled back into later shows."

There is also a scientific, empirical and, to a certain degree, ethnographic dimension to Obrist's practice. Like an old-fashioned explorer, he visits or rather maps art scenes of different continents, generations, and milieus. Mostly this happens through straightforward

10

travels, studio visits, meetings, and more recently, interviews. Considering the quasi-encyclopedic scope and ambition of his interviewing, one might say that Obrist is also an atypical art historian in the tradition of Aby Warburg. Without doubt his interviews will be, and already are, invaluable source material for researchers.

But his most important contribution, in my view, lies in the fact that he is (maybe more than he is aware of) searching for modalities in art that go beyond objecthood. As he phrases it in these pages: "We must experiment with ways beyond objects." Some, including myself, think that the notion of "art" that was generated via the material arts—sculpture and painting—in the early nineteenth century and was fully articulated and established by the 1960s, is detaching itself from its material origins and venturing into other realms. If this is true, then Hans Ulrich Obrist is definitely a case to exemplify this shift; after all, despite his various activities and modalities, he works under the title "curator," a person whose job it is to take care of objects worth preserving—a specialist of *things*. Now there is absolutely no talk of such matter in this book; in contrast, it is striking how not only prevalent but also dominant the trope of the encounter, of the conversation, one could say of the intersubjective, is in the interviews compiled here. Obrist is drawn to the field of art and especially to artists for their absolutely serious speculation about the future and its postures, attitudes, and modalities, but early on he intuitively sensed something reductive and lifeless in the way that the "exhibition" format focuses on the highly static human-to-object-relation. His issue (and mine for that matter) is that this relationship lacks dynamism and the interpersonal. Hence his venturing into other fields, his obsession with interviews, his extensive (and unrivaled) networking can be explained as an attempt to escape from, or at least add other modes to, the reductive focus on things that visual art propagates. This core feature of the (conventional) exhibition is absolutely incompatible with Obrist's thinking and philosophy

which—as it becomes increasingly clear the more inter-
views one reads—bears a strong cybernetic and vitalist
current. Instead, his ambitions are oriented towards
the intersubjective, like he says in my favorite sentence
of the book: "I've always wanted to make salons for the
twenty-first century. That is my great goal."

Similarly, one can repeatedly read Obrist quote the
artist Carsten Höller that the art world is still one of the
most interesting fields. Obrist refers to this frequently
as it was a big question for him around the mid-1990s,
as to whether or not he should leave the field of art. Fol-
lowing Höller's advice, he decided not to; nonetheless,
the frequency with which he brings it up hints at how
"constricting" he must have felt its formats to be. This
not only gives further evidence to my hypothesis that
overcoming the exhibition's usual subject-object relation
in favor of the intersubjective is his main driving force,
but it also sheds light on what he is up to now: with his
branching off into architecture, science, urbanism, and
politics, and especially his inventing of new formats like
the interview marathons or the "brutally early club"
(a salon in London which starts at 6 a.m.). One might say
that instead of leaving the art world, Obrist transcends
it, and is thus one of the people who has built it into
a marketplace of different fields and discourses that it
has come to be when at its best.

It is Obrist's ambition to always be guided by necessity
or "urgency," as he calls it. ("Its urgent!" has become his
most frequent expression in recent years.) His research is
aimed at finding out what is urgent to initiate right *now.*
It is precisely for this purpose that his "don't-stop" life-
style—which he developed as a teenager when taking
the train to a different European city every night to visit
artists and cultural edifices—is designed for. To this
day he has managed to more or less maintain this life-
style, the difference being that he now operates on a
global scale and takes the plane instead of the night
train. Noteworthily, he seems to be aware of the unsus-
tainability of the former, as he twice mentions Gustav

Metzger's proposal to stop flying; thus a project that urgently needs to be initiated that his otherwise very twenty-first-century lifestyle lacks: solar-powered forms of global travel.

Tino Sehgal

Before and After

with Enrique Walker (excerpts)
New York, March 27, 2008

Enrique Walker — *Lastly, I would like to discuss what precedes and what succeeds one of your interviews. Do you follow a tight script when interviewing?*

And after an interview is carried out, do you edit, and subject the recorded material to the problems of writing proper, or simply transcribe? In other words, is the ultimate product of your project a series of texts or a series of recordings?

Hans Ulrich Obrist — I have a large stack of cards where there are hundreds of different issues. Very often it is up to chance how these cards are sequenced and how questions are raised. In this sense, I am extremely prepared, but I also try to leave the conversation open to improvisation.

In our long conversation in London, we spoke a lot about transcription and editing. And I think our systems very much diverge on this matter. I think you believe in the idea of interviews being transformed into texts, while my interviews are more like direct transcriptions with less editing. The transcripts try to catch the rhythm or maybe the tempo of the spoken word; they try to stick as close as possible to the conversation. Since it is a conversation, it has to do with highs and lows, intervals, pauses, and silences. Joseph Grigely makes a distinction between a conversation and an exchange: a conversation is a synchronous communication in space and involves gestures, visual signals, and a variety of voices, whereas an exchange lacks the embodied presence of speech. Very often it falls between these two extremes.[1] And this obviously leads to the big problem of silences, because there are things we cannot transcribe.

1. "Joseph Grigely, an artist and critical theorist who became deaf as a result of a childhood accident, is best known for exhibiting compilations of scribbled notes written to him on odd scraps of paper by friends and acquaintances when he is unable to read their lips. Grigely's 'Conversations with the Hearing' usually take place during noisy social gatherings, where passing notes leaves behind a visible residue of the ephemeral flow of cocktail-party small talk." For more, see *artnet.com*.

...

...

...

I'll never forget the time when I went to see the philosopher Gadamer in Germany. He was about a hundred years old at that time, and I thought it was unbelievably urgent to interview him about interviews. He was alone in this very big house. And at a certain moment he fell asleep. I didn't know what to do because I did not dare touch the great philosopher. Time passed—ten minutes, fifteen minutes—and it was really scary. And then luckily the telephone rang, and he answered. Then he hung the telephone down [sic], and he looked at me and said, "We are going to have a problem here. How will you transcribe my silence?" So that's maybe an indirect answer to your question.

The
Future
Is
a
Dog

with Markus Miessen
London, November 6, 2007, 6:30 a.m.

Markus Miessen — *What is the first thing that comes to mind when thinking about the future?*

Hans Ulrich Obrist — People always ask me: what is the future of art? And I always think it is such a difficult question. Why would I, as a curator, predict the future of art? I am not a future-teller; I am not somebody who predicts the future. I am also not a futurist. And out of this malaise, because I was being asked almost weekly about the future of art, I thought it could be interesting to ask all the artists and architects I know and have worked with to tell me what the future will be, in one sentence. Every now and then I receive a new batch of futures. My laptop, an enfolded monster, holds a polyphony of futures.

According to Paul Chan, the future is going nowhere without us.

Damien Hirst says the future is without you.

THE FUTURE WILL BE CHROME Rirkrit Tiravanija * THE FUTURE WILL BE CURVED Olafur Eliasson * THE FUTURE WILL BE "IN THE NAME OF THE FUTURE" Anri Sala * THE FUTURE WILL BE SO SUBJECTIVE Tino Sehgal * THE FUTURE WILL BE BOUCLETTE Douglas Gordon * THE FUTURE WILL BE CURIOUS Nico Dockx * THE FUTURE WILL BE OBSOLETE Tacita Dean * THE FUTURE WILL BE ASYMMETRIC Pedro Reyes * THE FUTURE WILL BE A SLAP IN THE FACE Cao Fei * THE FUTURE WILL BE DELAYED Loris Gréaud * THE FUTURE DOES NOT EXIST BUT IN SNAPSHOTS Philippe Parreno * THE FUTURE WILL BE TROPICAL Dominique Gonzalez-Foerster * FUTURE? ... YOU MUST BE MISTAKEN Trisha Donnelly * THE FUTURE WILL BE OVERGROWN AND DECAYED Simryn Gill * THE FUTURE WILL BE TENSE John Baldessari * ZUKUNFT IST LECKER Hans-Peter Feldmann * ZUKUNFT IST WICHTIGER ALS FREIZEIT HELMUT KOHL proposed by Carsten Höller * A FUTURE FUELLED BY HUMAN WASTE Matthew Barney * THE FUTURE IS GOING NOWHERE WITHOUT US Paul Chan *

THE FUTURE IS NOW—THE FUTURE IS IT Doug Aitken *
THE FUTURE IS ONE NIGHT, JUST LOOK UP Tomas Saraceno *
THE FUTURE WILL BE A REMAKE ... Didier Fiuza Faustino *
THE FUTURE IS WHAT WE CONSTRUCT FROM WHAT
WE REMEMBER OF THE PAST—THE PRESENT IS THE
TIME OF INSTANTANEOUS REVELATION Lawrence Weiner *
THE FUTURE IS THIS PLACE AT A DIFFERENT TIME
Bruce Sterling * THE FUTURE WILL BE WIDELY REPRODUCED
AND DISTRIBUTED Cory Doctorow * THE FUTURE WILL BE
WHATEVER WE MAKE IT Jacque Fresco * THE FUTURE WILL
INVOLVE SPLENDOUR AND POVERTY Arto Lindsay *
THE FUTURE IS UNCERTAIN BECAUSE IT WILL BE WHAT
WE MAKE IT Immanuel Wallerstein * THE FUTURE IS
WAITING—THE FUTURE WILL BE SELF-ORGANIZED
Raqs Media Collective * DUM SPERO / WHILE I BREATHE,
I HOPE Nancy Spero * THIS IS NOT THE FUTURE Jordan Wolfson
* THE FUTURE IS A DOG / L'AVENIR C'EST LA FEMME
Jacques Herzog & Pierre de Meuron * ON ITS WAY; IT WAS
HERE YESTERDAY Hreinn Friðfinnsson * THE FUTURE WILL
BE AN ARMCHAIR STRATEGIST; THE FUTURE WILL BE
LIKE NO SNOW ON THE BROKEN BRIDGE Yang Fudong *
THE FUTURE ALWAYS FLIES IN UNDER THE RADAR
Martha Rosler * SUTURE THAT FUTURE Peter Doig *
"TO-MORROW, AND TO-MORROW, AND TO-MORROW"
(Shakespeare) Richard Hamilton * THE FUTURE IS OVER-
RATED Cerith Wyn Evans * FUTURO = $B!G (B Héctor Zamora
* THE FUTURE IS A LARGE PHARMACY WITH A MEMORY
DEFICIT David Askevold * THE FUTURE WILL BE BAMBOO
Tay Kheng Soon * THE FUTURE WILL BE OUSSS Koo Jeong-A
* THE FUTURE WILL BE ... GRAINS, PARTICLES & BITS.
THE FUTURE WILL BE ... RIPPLES, WAVES & FLOW. THE
FUTURE WILL BE ... MIX, SWARMS, MULTITUDES. THE
FUTURE WILL BE ... THE FUTURE WE DESERVE BUT
WITH SOME SURPRISES, IF ONLY SOME OF US TAKE
NOTICE Vito Acconci * IN THE FUTURE ... THE EARTH AS
A WEAPON ... Allora & Calzadilla * THE FUTURE IS OUR
EXCUSE Joseph Grigely and Amy Vogel * THE FUTURE WILL
BE REPEATED Marlene Dumas * OK, OK, I'LL TELL YOU
ABOUT THE FUTURE; BUT I AM VERY BUSY RIGHT NOW;

GIVE ME A COUPLE OF DAYS MORE TO FINISH SOME
THINGS AND I'LL GET BACK TO YOU Jimmie Durham * FUTURE
IS INSTANT Yung Ho Chang * THE FUTURE IS NOT Zaha Hadid
* THE FUTURE IS PRIVATE Anton Vidokle * THE FUTURE
WILL BE LAYERED AND INCONSISTENT Liam Gillick *
THE FUTURE IS A PIANO WIRE IN A PUSSY POWERING
SOMETHING IMPORTANT Matthew Ronay * IN THE FUTURE
PERHAPS THERE WILL BE NO PAST Daniel Birnbaum * THE
FUTURE WAS Julieta Aranda * THE FUTURE IS MENACE
Carolee Schneemann * THE FUTURE IS A FORGET-ME-NOT
Molly Nesbit * THE FUTURE IS A KNOWING EXCHANGE OF
GLANCES Sarah Morris * THE FUTURE: SCRATCHING ON
THINGS I COULD DISAVOW Walid Raad * THE FUTURE IS
OUR OWN WISHFUL THINKING Liu Ding * LE FUTUR EST
UN ÉTOILEMENT Édouard Glissant * THE FUTURE IS NOW
Maurizio Cattelan * THE FUTURE HAS A SILVER LINING
Thomas Demand * THE FUTURE IS NOW AND HERE
Yona Friedman * IS A FAX BEST TO USE AS FACSIMILE G&G
FAX IS: THE FUTURE? SEE YOU THERE! AS ARTISTS WE
WANT TO HELP TO FORM OUR TOMORROWS. WE HAVE
ALWAYS BELIEVED IN THE PAST, PRESENT AND FUTURE.
IT'S GOING TO BE MARVELLOUS. LONG LIVE THE FUTURE
WITH LOTS OF LOVE ALWAYS AND ALWAYS Gilbert & George *
THE FUTURE IS WITHOUT YOU Damien Hirst * THE FUTURE
IS A SEASON Pierre Huyghe * THE FUTURE IS A POSTER M/M *
WE HAVE REPEATED THE FUTURE OUT OF EXISTENCE
Tom McCarthy * THE FUTURE HAS TWO LARGE BEAUTIFUL
EYES Jonas Mekas * LESS, FEW TOURS IN MY FUTURE
Stefano Boeri * FUTURE IS WHAT IT IS Huang Yong Ping *
THE FUTURE IS THE VERY FEW YEARS WE HAVE REMAINING
BEFORE ALL TIME BECOMES ONE TIME Grant Morrison *
FUTURE MUST BE HERE TODAY Jan Kaplický * FUTURE
IS MORE FREEDOM Jia Zhangke * MY ART IS VERY FREE;
I DON'T KNOW WHAT TO DO IN THE FUTURE BUT I AM
POSITIVE Xu Zhen * THE FUTURE IS INSIDE Shumon Basar,
Markus Miessen, Åbäke * NO FUTURE—PUNK IS NOT DEATH!
Thomas Hirschhorn * THE FUTURE WILL BE GRIM IF WE
DON'T DO SOMETHING ABOUT IT Morgan Fisher * THE
FUTURE IS REFLEXIVE AND COMING TOGETHER

Olafur Eliasson * THE FUTURE IS LISTENING Shilpa Gupta
* THE FUTURE LIES IN THE UNKNOWN Ann Lislegaard *
NOTHING STINKS, ONLY THINKING MADE IT SO
Sissel Tolaas * DIE ZUKUNFT KANN MAN NUR UEBER
NACHT DEFINIEREN Peter Sloterdijk * THE FUTURE IS
A DISEASE Peter Weibel * FUTURE >< PAST Susan Hefuna

As the title of Oliver Payne and Nick Relph's book We Don't
Have the Option of Turning Away from the Future *implies,
we seem to be part of a lineage that never stops. However,
there are breakages, stoppages, turns, and dead ends. You
have done many projects that anticipate the future as some-
thing operative. Can you tell me about the formula project?*

The formula project is one of many ongoing, immate-
rial exhibition strings. The first of these projects was
"do it": an exhibition that consisted of recipes. It is all
about the idea of how art can travel without having to
send objects around the globe. Objects in most cases
are not forever anyway. As Cedric Price pointed out,
everything has a limited life span. If you look at this
building here on Hereford Road, these bricks, if they
aren't demolished, will have to be replaced one day.
If you look at art history, it is very much a history
of the object. So the question became: What could
be the scores, what could be the instructions? The same
goes for architecture: What, for example, is the score
for rebuilding the Barcelona Pavilion? What are the
drawings that enable that process? If you look at pavil-
ions, there are often a set of drawings and scores so
that in the future it can be rebuilt. I just came back
from China where we launched the Chinese edition of
"do it," which has happened in more than forty museums
already. These are projects that are not crated or put
in boxes; they consist of ideas. So besides the physical
exhibitions that I do, I have this parallel reality: my
dematerialized exhibitions. So after "do it," I worked on
many different projects related to the idea of lists. The
futures list is one of those. The unrealized projects list

is another one. Two years ago at Art Basel, I interviewed Albert Hofmann, the pioneering chemical inventor of LSD. During the interview, Hofmann sketched the formula for LSD on a piece of paper. I was compelled by the simplicity of the drawing. His biggest invention, his whole life's work, had just been condensed to fit onto A4 sheet of paper. And that triggered it for me, that was the reason for going out and asking artists and architects for their equation for the twenty-first century. I went back to London and put the LSD formula on my office wall. But little by little, more formulas were added to it. By the time that I had worked in London for a year, the whole office was completely filled with formulas. <u>It's a conversation piece; my projects often have something to do with conversations.</u> So artists who visit my office would look at what the others had done, and then they would e-mail me their own formula.

And now it's going to be a book.

<u>Yes, as Lawrence Weiner once said, "Books furnish a room."</u>

So what makes this project operative for you?

It has a ripple effect. It is about the facilitation of flows, allowing flows to happen. One night Brian Eno told John Brockman, the founder of the Edge Foundation, about the formulas, and so he came by my office to look at them. He got really excited and thought that maybe everybody in the Edge community might want to contribute a formula as well. This is very clearly going to become much more important for me. I haven't really done that many exhibitions online. This is now something that I want to expand on.

One could argue that your entire practice is about the future.

I am driven by curiosity; I want to understand how things evolve.

You have been called a truffle pig, someone who detects currents and trends before they occur. Where are we going? Not in terms of artistic and spatial practices, but more generally speaking.

We just had a brainstorming session in Beijing at Vitamin Creative Space about where people think we are going. A few key words started to emerge: place; vacancy; agency; dangers of neo-colonialism; slowness; technological, cultural, and demographic shocks; and the idea of a new feminism. These ideas came up again and again from Chinese artists as some of their key topics for the twenty-first century.

What do you consider radical right now? What might be radical in the future?

Memory. Memory is very radical right now. My obsessive interviewing with very old practitioners, those who are almost one hundred years old, clearly has to do with Eric Hobsbawm's protest against forgetting. In the world in which we are living—one constantly defined by newness—nobody talks about age.

How do you think of Switzerland when thinking about the future?

Growing up in Switzerland was a great preparation for my later work because of its polyglot environment. The immersion in languages was actually a form of preparation for my departure. But at the same time, there was a sensation of narrowness. The mountains in Switzerland block the sea. However, in the digital age and the era of increased intercontinental traveling, the Swiss experience such feelings of narrowness much less. It has become more possible for artists and architects to live there. I actually think that Zurich is a really fascinating place.

How do you feel about opposition? Does it allow for productive exchange?

I think more about resistance. Just before Jean-François Lyotard died, he wanted to do an exhibition about resistance, which is actually a show that I have been thinking about with Philippe Parreno and Daniel Birnbaum. The notion of resistance is incredibly interesting right now. Robert Rauschenberg said in an e-mail I have here from Philippe Parreno: "Silence as an artistic strategy should not be understood as mere political indifference. Rather it can be conceived as a strategy of resistance [...] that opposes hegemonic cultural values by opening the processes of perception and interpretation to other voices and points of view. It is an anti-authoritative mode that is not oppositional."

Cedric Price used to go to the British Museum at 3 p.m. every day to distort place and time and think about the future. What's your equivalent?

My equivalent is the conversation project, the ongoing project—it's my oxygen. Every day I speak to scientists, architects, and artists. This is my ongoing research. This is my British Museum.

Originally published in *BUILD* 6 (December 2007).

The Elephant Trunk in Dubai

with Ingo Niermann
Dubai, Mina A'Salam, May 28–29, 2007

✳✳

*May 28, 2007, a little after midnight. Hans Ulrich Obrist is
in Dubai at the invitation of the International Design Forum.
His accommodation is at the Mina A'Salam, a luxury hotel
part of an aquatic landscape reminiscent of Venice, but also
of an Arab citadel, not far from the Burj Al Arab. We sit in
the lobby on an arabesque group of sofas. Obrist has arrived
from London the previous evening. Thanks to the three-hour
time difference, it shouldn't really be that late for him, but he
orders three cups of coffee and a fourth a little later: "Two
is a company, three is a crowd, what is four?" He reassures
the irritated waiter: "I'm totally serious. Trust me!" The waiter
places the cups on the table, and pours a glass of water
next to each one. Obrist is reminded of Parisian cafés with
their small tables: "I always ordered seven espressos there, and
then they brought six more chairs." Indian or Pakistani workers
begin to first vacuum and then polish the marble floors.*

✳✳

Ingo Niermann — *What did art mean to you during the different phases of your life? For instance, when you were in school, at the time of your first fascination?*

Hans Ulrich Obrist — I've got to think about that for a while, that's a difficult question. The problem is that it always leads to such clichéd notions. You can neatly arrange these things in hindsight, but how does a fourteen-year-old in Switzerland suddenly come to see exhibitions every day, and then as a seventeen-year-old call Fischli/Weiss, and as an eighteen-year-old, while on a school trip to Paris, call Christian Boltanski and Annette Messager and then visit them? Soon after, I went to London to see Gilbert & George, and I met Gerhard Richter. I then frequently took night trains through Europe—in 1986–87. There was the Interrail ticket, on which young people could travel across all of Europe for a month, and I took night trains again and again so that there were no hotel expenses. While on these trains, I frequently mused that everything had really already been done. There was a very sophisticated art system, even then, so what would be a really pioneering act? Then it took relatively long—from this early research to my kitchen exhibition in 1991. Four or five years had passed. I was everywhere, all the time, but I had yet to produce anything. Those were apprenticeship and journeyman years, a European Grand Tour.

Fischli/Weiss had then told me that I absolutely ought to visit Alighiero Boetti during a school trip to Rome. That was a crucial experience. Boetti said: now this is all very remarkable, that someone knows at such a young age that he wants to work with art. But somehow it wasn't clear to him what it really was I wanted to do. And he also said that the offers he received always came down to the same: museum exhibitions, gallery exhibitions, and boring or less boring books. But he also had, he said, many projects; for example, he would love to print thousands of puzzles for an airline and distribute them to the passengers. So I thought that this

wouldn't be such a bad approach: to begin with what artists really want to do and to ask them about their unrealized projects, and then to change the world—this was perhaps a little naïve—in such a way that these projects would be able to take place. A few years later, we took the museum in progress to Austrian Airlines and said that we wanted to do this, and a few weeks later it took place. Or Boltanski said he'd always wanted to exhibit at a monastery. So I saw the abbot in St. Gallen and kept talking at him until we did the Boltanski exhibition there. Richter talked about Nietzsche, and then we exhibited at the Nietzsche House. And all of that was always possible one way or another.

Is that also how the first show you curated, in your kitchen, came about? Because artists said they would like to show in a kitchen for once?

No, but Fischli/Weiss, Boltanski, and Richard Wentworth noticed that I never cooked anything, that there were only books in the kitchen. The idea was then that Fischli/Weiss would turn the kitchen into a kitchen with an exhibition, and they constructed this altar made of oversized groceries.

But your role today is a more active one than just fulfilling wishes like a good fairy.

[laughs] What I can say is this: the whole curatorial thing has to do not only with exhibitions, it has a lot to do with bringing people together. That is a large part of my work.

In earlier times there were the salons.

I've always wanted to make salons for the twenty-first century. That is my great goal.

You had Salon 3 in London.

That was with Rebecca Gordon Nesbitt and Maria Lind. In 1999, we created a small salon at the Elephant & Castle where weekly conversations took place and small exhibitions. It was formalized a little there. But I'm trying to create this salon wherever I am. Bringing people together who wouldn't otherwise meet, <u>to go beyond the fear of pooling knowledge</u>, so to speak.

This also went further later on, from art into science, into literature, into architecture. <u>I flirted with leaving the art world as early as the mid-1990s, perhaps for architecture. It was all too constrictive; but as Carsten Höller once said to me: it is the least bad place</u>. And that's how these bridges across disciplines came into being. I curate art; I curate science, architecture, urbanism.

Why is art so especially suitable for such excursions; why has it today become this gigantic trunk that sucks everything in? Was it already inherent in Velázquez that you would at some point be able to sit even at the Jülich research center and it would be art?

That is a very interesting question, though I couldn't say with certainty whether it goes that far back. But what I can say is that all of this has to do with my Ur-experience: an exhibition by Harald Szeemann, "Der Hang zum Gesamtkunstwerk." However, I've never worked with Szeemann and he was never my teacher in a direct sense, in the way that Kasper König and Suzanne Pagé were.

"Der Hang zum Gesamtkunstwerk" was an exhibition about the most diverse forms of the Gesamtkunstwerk—in Gaudí, in Steiner, in Beuys, and Schwitters. And I believe that almost any project I have done can really be traced back to this early experience. I think that his exhibition, in its proximity to ideas of utopia, stood also at the beginning of my interest in unrealized projects. I saw this show something like forty times. I went back to the Kunsthaus Zürich every afternoon,

even skipped school. It was like learning a long play by heart. It was a total obsession.

There was such megalomania reaching across the borders between disciplines in early twentieth-century music, architecture, literature—D'Annunzio ...

There's always also the totalitarian danger that comes with the Gesamtkunstwerk.

... and today this "reaching-across" is left to art alone?

I don't know because I think that in the end, someone like Rem Koolhaas is working on the same thing. Perhaps it's simply a structural and economic question that art is at the moment the only field. And then at the same time, it's not quite true; our opera project "Il Tempo del Postino" is happening on a budget that comes from a music and opera festival.

There's really much more money there.

There's real public support.

This suction now exists also in theater, but it's my impression that they're a step behind.

I think that the notion of the curator may play a role. In other fields, this idea of the curator doesn't really exist. For instance, I don't know who the most interesting curator of literature would be. There are editors and publishers, but they immediately have a commercial interest and are bound by it.

There are festivals, but they have no productive effect. The authors come, read, and leave.

The curator, like an editor, used to be firmly associated with one museum, and then this notion of the

independent curator came into play with people
such as Szeemann. That's the milieu into which I was
born. I grew up in Switzerland during the heyday of
Harald Szeemann. During that same time, there was
also Kasper König in Germany, and after my teenage
years in Switzerland I immediately started working
with him in my early twenties. I went to Frankfurt
and worked with him on the book *Der öffentliche Blick*
and the painting exhibition "Der zerbrochene Spiegel."
There was already a pretty large public for that, which
had to do with this climate in the early 1990s when
everyone was suddenly looking for a new generation.
At the same time there was a recession, which was
also important. There was a lot of leeway. There was
suddenly a lot of oxygen.

*With all the dynamism that art has developed, the constant
transgression of borders—what is art?*

I think that the attempt to find out what art is is really
the permanent process. If we had an answer to this
question, we'd probably stop.

But did you have answers sometimes?

Nietzsche said that art is the desire to be different,
to be elsewhere.

And what were your answers?

Before my first encounter with Fischli/Weiss, there
was a bulimia of sorts. I was out and about as an
adolescent, looking at everything and interested in
everything. And with my encounter with Fischli/Weiss
a critical consciousness, no, a critical way of looking
emerged. I often went to visit them at their studio on
afternoons when there was no school, and they asked
me: "What have you seen?"

How did your interest in modern art develop? Did your parents take you to the museum?

No, I was more of an autodidact. During that time, I began to buy art postcards, which included everything from Impressionism to Expressionism to Hodler. Hodler was important. I think that the Kunsthaus Zürich was an important point of reference. Giacometti. The Segantini Museum in St. Moritz was also important. Segantini, the man who always said, "I want to see my mountains."

The school of the nineteenth century. Art students are still trained in nude drawing and oil painting, and even those who later become conceptual artists have gone through this, like an embryo-stage.

Anri Sala's sister told me that when Anri was five, he drew soccer from the TV.

Olafur Eliasson was once a painter.

I actually went the other way. I didn't come from art history but studied sociology, political science, and economics instead. In this sense, my experience of art always had its point of departure in the present. The past is dynamically generated from out of the present.

Why didn't you study art history?

As I knew that I wanted to work with artists, it felt important to open my studies up to other fields of knowledge. There have been many exhibition-makers who came from other disciplines. Franz Meyer was a lawyer; Kasper König studied anthropology at some point. Willem Sandberg, the greatest of all post-war museum directors, was a graphic artist and anarchist. Harald Szeemann came from the theater.

And did you ever consider becoming an artist yourself?

No. That was perfectly clear from the beginning. Mediation was the point. This also had to do with the fact that if you grew up in Switzerland at that time, there was this whole literature on exhibitions by Szeeman called *The Museum of Obsessions*, which was really present.

Did you think that the curator really creates an über-Gesamtkunstwerk?

I'd gone to this show [Szeemann's "Der Hang zum Gesamtkunstwerk"] over forty times and still hadn't seen everything, and then I thought that it would be interesting to make exhibitions myself at some point that would be this dense.

⁂

One o'clock. The waiter asks for our last order. Obrist: "Maybe one more coffee." But the machine has already been cleaned. Obrist: "That's a tragedy. What a devastation." He orders a diet coke.

⁂

Nine years passed between your first interest in art, awakened at the age of fourteen, and your first show. You made a name for yourself with uncommonly small exhibitions—in your kitchen, at room 763 of the Paris Carlton Palace, and the Robert Walser Museum consisted of a single exhibition vitrine. But then, like a Big Bang, an enormous expansion ensued.

I've always regarded it as more of an almost schizophrenic situation in which the two coexist: large and small. With Kasper König in 1993, it went directly from the smallest to the largest space. We co-curated "Der zerbrochene Spiegel," an exhibition of paintings by forty-four artists. The hotel exhibition was a response

to the proposition of showing seventy artists not in a hundred thousand square feet but in a hundred. And even at the time of "Der zerbrochene Spiegel," the Robert Walser Museum was very important. I worked on this large exhibition in Vienna and then went back to Gais in Appenzell and installed a vitrine for ten people. So in this sense it's always been an oscillation.

The profession of the curator is less public in France, and one could simply work in quiet in Paris. After moving to the Serpentine Gallery last year, the work is much more public, since London is quite the opposite of Paris. <u>London is like a gigantic microphone. It's like what General Giap once said, when you gain in territory, there's always the danger that you'll lose concentration in turn</u>. I think it is no accident that the necessity now arises to return again to this kitchen exhibition. What is happening at my Berlin apartment right now has much to do with this. Twenty-thousand of my books that have been in Lüneburg for years are being sent to my apartment in Berlin. Anri Sala is shooting a film there, and we will install this film in the apartment. That is going to be a very intimate exhibition. The idea is that the film will always be playing, even when no one is there.

The oscillation between small and large is only making your workload even bigger.

[laughs]

Do you think that you've reached a limit by now: More exhibitions, more travels, more books, more interviews in a year can't be done?

That's never been the question in this format, because it is always necessary to do something. There is always a limit like that because frequently no more is possible, but at the same time, there's never been a choice.

You haven't had to renounce anything?

The most unbeatable argument as to why someone has no time came from György Ligeti. This was my big unrealized interview. I spoke with his office on the phone again and again; things went back and forth and back and forth. At some point I got Ligeti himself on the line, and he told me: "You've got to understand, I'm now seventy-eight years old, my health isn't so good, and I still have more than thirty years of music to write." What are you going to say to that?

You never have enough time and yet the point is again and again to make time free, to liberate time.

There are different limitations: your physical powers decrease, or that traveling annoys you too much—having to make the trip out to Heathrow for the umpteenth time. Do you have that sense?

No. It's almost my most powerful memory of London, this music on the train to Heathrow, like a strange soundtrack. Not music for an airport, but music for an airport train—more like elevator muzak. The Heathrow Express feels like a horizontal elevator.

None of this is all that interesting, because the jetting around and all that, you could just as well stop doing it tomorrow. And <u>perhaps it would indeed be better, as Gustav Metzger always says, if the art world were to stop flying</u>. Whether I spend a day in Berlin or London, or I spend a month in Berlin or London, it's not as though the intensity decreased because of that; on the contrary, it becomes greater. The places where I live become places of more profound research. It's a don't-stop procedure.

Do you still sleep so little?

<u>Sleep to me is like an accident</u>, because I really don't want to sleep, and yet sleep outwits me again and

again. Which is to say, at some point every day, I fall
into a state of sleep for a number of hours.

And then you sleep uninterruptedly?

Now uninterruptedly, yes. That has changed, too.
<u>At some point there was the da Vinci rhythm: you sleep
for fifteen minutes every three or four hours</u>.

And you woke up on your own?

With a big alarm clock. So you sleep only one and a
half hours a day and you're always fresh. That's very
productive, but then it didn't agree with my office
hours. Suddenly lying on the office floor in the middle
of the day was too weird.

In the beginning, in the early 1990s, it was really
extreme, because then it was about sleep deprivation.
But now that's really not so much the game anymore.
Now it's rather that sleep does take time away, but, at the
same time, it also re-edits the remaining time such as to
make a day become like a week.

Because I now have an office and I am there on
weekdays, I often travel only on weekends—two days in
China one weekend, two days in Berlin on another. And
when you are abroad for only twenty-four or forty-eight
hours, everything suddenly becomes a very long period
of time. In China, twenty-four hours become like a week
because you pack an incredible amount of things into
these twenty-four hours.

In most cases, you also already know the places.

These are frequently repeated visits; it's a sort of rapid
update. So to that extent it's less traumatic. The first
trips where I went to Asia, to the Middle East, and
began to research everything from the ground up, these
were extremely intense trips. I traveled through South-
east Asia for weeks with Hou Hanru, the co-curator of

"Cities on the Move." I hardly slept for days and attempted to understand all that. The update is easier, yes.

Do you still drink that much coffee all day?

Only when the fatigue becomes acute. Right now, I drink very little coffee. <u>In the beginning, in the 1990s, I was having fifty coffees a day. Like Balzac</u>. As to Balzac's productivity—how many books did he write? An insane amount of books.

They say he died of his addiction to coffee.

Relatively young.

At fifty-one.

A sad way to go.

Did you no longer take the coffee well?

No, at some point it simply abated, so that I now drink coffee only at extreme moments and no longer all day. When I still had the da Vinci rhythm, I always drank a great amount of coffee before going to sleep so that I would be awake again after fifteen minutes. That works.

Were there any side effects?

Side effects? Somehow I can't think of anything anymore. I think we'll really have to continue this tomorrow.

⁂

It is a quarter past two. At 6 a.m., I receive a text message: "It only just began." The following evening, Obrist and Rem Koolhaas are holding an interview marathon together. It is scheduled from seven to eleven, with more than a dozen Arab interview partners. In fact, it runs well past midnight. By the

43

*time we sit once more in the lobby at the Mina A'Salam, it
is a quarter past two and the workers polishing the floors are
exactly where we left them the night before. This time, Obrist,
after some persuading, successfully redirects the 24-hour
room service to the lobby and receives a large thermos of
coffee. At half past four, we are served diet coke and two
cardboard boxes of pizza.*

<div align="center">**</div>

Have you ever tried stimulants other than coffee?

Art is my stimulant.

Not even caffeine pills?

Most rarely. Guarana.

*You made notes during our conversation last night. What
is going to happen to them?*

There are stacks with lots and lots of notes—scribbles
from lectures and interviews. It has to do with a terrible
phobia I have of speaking in public. And the only way
for me to survive this is to make notes all the time, and
to videotape everything. It's a diversion of sorts that
makes the whole thing a little less dramatic.

You preserve all of it?

Yes, it's all preserved.

How?

It's all a gigantic chaos; the apartment is full of mate-
rials. And then specific aspects again and again
go through a review process with a view to specific
projects. But since the production is a lot faster than
the review, it takes years. The review happens only

when there is an occasion. The interviews were in a state of total chaos when they were first put together for the voluminous Charta book four years ago. Now we're slowly beginning to develop this video archive—there are people who want to do something with it. There was also a request to make DVDs from it. The notes were never put in proper order, and at some point Michael Diers, the German art historian specializing in archives, asked me to send them to him. These are nonlinear books. When I write texts or books of some kind or another, these thousands of pages from some lecture or conference are processed into these texts. I write texts very rarely, so these large collages emerge two or three times a year.

You have people who begin by transcribing all of it for you?

With the interviews, it's like a text-machine. PhD students transcribe them into various languages, because I conduct the interviews in Spanish, Italian, English, French, German, and sometimes in Russian.

The whole thing is a gigantic zero-sum calculation in Bataille's sense. Whether it is the hundreds of lectures or the many, many interviews that are being published, or the many exhibitions, they all continue to produce further production. And at the same time they cause horrendous expenses: horrendous transcription expenses and horrendous travel expenses. I have never had the time to worry about it. I have always operated at such a frenetic pace—one that produces a great amount of content but just enough money so that I break even.

Earlier, on our way to the hotel, you told me that in art, money is the hardest question of all.

During the early 1990s, you didn't think about money for months. Living expenses were extremely low.

Flights weren't any cheaper then.

But night trains were.

And today?

I do think that this has become a relatively difficult question now, because suddenly so much in the art world is revolving around money; while on the other hand, parts of the art world still have nothing to do with money. It's like parallel worlds, as David Deutsch describes in *The Fabric of Reality* [1997].

Today there also exist two corresponding kinds of artists: those who mainly sell art, and those who rather tour the international large exhibitions and biennials and live on allowances and stipends.

Ten minutes before we met, Daniel Birnbaum sent me an e-mail: Derrida wrote in 1967 about the exhaustion of the book, alluding to the convulsive proliferation of libraries. I've often had the discussion with Daniel that the biennial as a format may have exhausted itself. This seems ridiculous, seeing that there are so many biennials all over the world. And yet the format has been exhausted, just as the novel was exhausted by the sixties. There are then very different possibilities: you no longer make biennials. Or as Daniel asks: "Is there some way to make this predicament more productive? Can you once more do what Gerhard Richter did in such a magnificent way: transform the possibility of impossibility into art?"

The history of the exhibition in the twentieth century was written as a radically experimental history. Space was created over and over again in ever-changing ways. Radical display features from Duchamp's coal bags to Yves Klein and Arman: *Le Vide* and *Le Plein*—the empty gallery, the replete gallery. All these radical gallery gestures that were played out were leitmotifs of the twentieth century. Perhaps, we only remember those exhibitions

that also invented new display features; and yet, it is still possible in exhibitions—although it has become increasingly more difficult—that every couple of years you find a missing link of some kind. "do it" was that kind of missing link. We were sitting in a café with Christian Boltanski and Bertrand Lavier ... such inventions—invent is a big word, they are small, modest inventions—when I succeed in inventing something, it's always in a dialogue with artists. For instance, in the case of "Utopia Station" it was with Rirkrit Tiravanija. With "Point d'ironie" it was once again with Boltanski. With the kitchen exhibition, the was with Boltanski, Richard Wentworth and Fischli/Weiss.

In some way it's also scientific, because you really look at everything that's been done in this field, and at some point, suddenly, there's a missing link. And where there's a missing link, there's also the utter urgency to realize it.

Here we are at a conference in Dubai—and while the entire history of the exhibition in the twentieth century was one of experimentation, the symposium, the colloquium, or the conference as production of knowledge were completely neglected. They really always follow the same ritual: a lecture with questions or a roundtable discussion with a few questions at the end and a moderator. So to that extent it's much easier here. For me, this suddenly became an incredibly open field, because simply nothing has been invented yet in terms of real rules of the game. That is then where things come from, such as the interview marathon with Rem Koolhaas, or "Art & Brain," the conference with Ernst Pöppel at the Jülich science compound, which was canceled and consisted only of a coffee break. Or for example, when Carsten Höller picked magic mushrooms.

Do you sense an increased pressure toward commercialization also in public institutions?

I have always tried to open up possibilities where one could work freely. By being out in the world and traveling constantly you attempt to see these various

openings. Be it in Antwerp with our large laboratory exhibition—that was the niche of a van Dyck exhibition. So in van Dyck's wake, Barbara Vanderlinden and I could make a very ambitious, experimental exhibition that was seen by perhaps only two thousand people. They said: van Dyck is the blockbuster, and now you young curators go ahead and make the most radical show, without any pressure to bring in incredible visitor figures. <u>It was more important how many hours the visitors spent in the show. It's better to have a few thousand spend an entire day with the show rather than 300,000 run through it</u>. And it's not the big cities, it's not Paris, New York, London; it's Bordeaux: "Mutations" —the French millennium exhibition on urbanism. That's where Stefano Boeri, Rem [Koolhaas], Sanford Kwinter, and I worked on a large-scale urban laboratory. Manchester 2007—a festival, a city wants to rebrand itself, and Philippe Parreno and I curated the opera "Il Tempo del Postino," an exhibition that is not about objects. Artists are not allotted space, but time. And what do curators do? Curators write a preface, a wall text, and then the wall labels are written. And in our exhibition a ventriloquist will speak instead.

People usually tend to overlook the curator's preface. This time they'll all have to listen.

No escape.

Does that create a special pressure?

The interesting aspect is that it sums up many things that we have been working on for a long time. Because I began to make exhibitions in the early 1990s, with a whole generation of artists to whom time was very important, the question was always: How can one bring this time protocol into the exhibition? I curated a Philippe Parreno show called "Alien Seasons" in which the most different works were activated. Jaron

Lanier, the inventor of virtual reality, programmed a fish, which triggered different projections in the space depending on its color. And while working on this exhibition—this is six, seven years ago—Parreno and I spoke often about what it would be like if we were to apply this question of the time protocol to a group exhibition. The artists in an exhibition would not be allotted space, but time. And all of a sudden it became clear to us that the museum was not the right place for this project, that it would have to be an opera house or a large theater instead. This remained an unrealized project because no opera house really wanted to get involved in it. At some point, Alex Poots, the director of the Manchester International Festival, came into play. We then meditated over the title for a long time: the French *facteur temps* is, on the one hand, the time factor, but also the postman time. And we thought that an opera would have to have an Italian title, hence "Il Tempo del Postino." Which is also the postman in Pasolini's *Teorema*, who is an angel.

Art continues to be, for the large part, a story of objects. And precisely at a moment when there's this exhaustion of formats, Manchester shows that the artistic contributions that do stand a chance of lasting may well be those of words, dance, and music, and not necessarily only objects. Doris Lessing's novella *Mara and Dann* which is about the ice age, describes how fragile our entire culture is and its objects along with it. I often think about the fact that scores tend to survive quite well. This was already a theme in my exhibition "do it" —the instruction, not the object, is the work. The instructions can be interpreted in different ways, like a recipe—which takes us back to Surrealism, Constructivism, and Dadaism. All the activities of these movements included much that did not exclusively have to do with the plastic arts. They were about theater, cabaret, and writing. When I was still in high school, I discovered this book by the great Alexander Dorner, *The Way Beyond "Art."* It became a little bit of an instruction

manual for me. In it he describes that we can understand the forces at work in the plastic arts only when we understand what's going on in other disciplines.

But aren't today's biennials generally already conceived as comprehensive of the different arts?

They wear themselves out in a repetition of patterns: there are fifty artists, and every artist has this and that amount of space. <u>I think that routine is the exhibition's greatest enemy</u>. If we're now doing this opera, and a permanent panic, an agony comes into play—it's like the first time, like with the kitchen exhibition. For me, it's in the end always about finding this moment again. In that sense, every show might also be the last one.

And still, I've also always been interested in reviving exhausted formats. After all, I want to work with all formats. I've also worked a lot with this notion of the national exhibition: English art—turned it around completely and made it into "life/live," a self-organizing complexity machine. Or "Nuit Blanche," about the Nordic art scene—doing post-national, national exhibitions (both of which were co-curated with Laurence Bossé). Or take the format of the monographic exhibition. After testing all imaginable typologies—group exhibitions and biennials, exhibitions at unconventional sites, etc.—I decided in 2000 to settle at an institution, the Musée d'Art moderne de la Ville de Paris, simply based on the consideration that as a free curator, you don't actually ever curate monographic exhibitions.

It was never a master plan. It was always more like Robert Walser's *flânerie*. Robert Walser went to Berlin, that was his exile, and then there was the fictional exile with the *Gazettes Parisiennes*. And then there was the exile within. These different levels of exile—if there was anything like a master plan, this was perhaps it.

And what in your work corresponds to these exiles?

That remains to be seen, after all. It has all just begun. Perhaps at some point I will only go for walks. I don't know.

You might see one part of your work as an exile from its other parts.

It has always somehow been like that. A design conference such as this one in Dubai, or when I immerse myself in the world of science—there's almost no one there from the art world. I often attend the kind of congresses where I know no one. I'm on panels at media conferences such as DLD [Hubert Burda, Stephanie Czerny and Marcel Reichart's Digital, Life, Design conference]. And then there was the whole interview project.

Curating, after all, produces ephemeral constellations that disappear, and, as a consequence, there are no memories of curating. My whole obsession with the archive has, of course, also to do with this: ~~the protest against forgetting~~. The interviews were an opportunity to immerse myself in all these other disciplines; they were my permanent education. <u>And most of my interviews were never published</u>.

There was suddenly this overexposure, as early as 1993. Everyone thought all at once: yes, a new curator, and there were a great number of articles and interviews. I had hardly done anything, and this was also the beginning of the incredible forces of globalization that have exerted an influence on the art world. Not yet China and India, but Japan came into play, and I was now constantly on planes. Starting out with nothing, with the kitchen, and becoming a world curator within a year—this shock destabilized me; it was a rather confusing situation. And then there was a key conversation with <u>Thomas Bayrle that really saved me. He took me aside and said: it's really quite simple, you've always got to have yet another activity that no one knows about, and then everything is alright</u>. Building

a reservoir of ideas that you don't exploit right away. It's like having a garden with fallow land so that things can grow there later as well. Everything you've done having already been published. That's really difficult, as one can easily run out of steam. It has actually been like this only since the eighties, at least in the art world. If you look at Giacometti's or Duchamp's biographies, they often didn't show for years. It's a marathon and not a sprint. Bruce Nauman saw this coming already in the 1970s when he said that overexposure is the main problem

You're simply so fast that the art business can't keep up, or keep track of where you're now bustling about. Or the publishers can't print the interviews fast enough. But there are also other things that you hold back on purpose?

Yes, of course. For instance, the entire thing with literature has really been going on since the beginning, because everything began with literature—with Robert Walser. That is something I've been determined to hold back for years because I didn't necessarily want to make a big exhibition right away about art and literary references, but rather now, very slowly, with the Lorca Foundation. ... There is the Lorca Archive in Granada, where Lorca's house also stands. That's another Robert Walser-like *flânerie* thing: along the way I keep encountering not only people but also the most diverse houses. This is the continuation of my kitchen exhibition: these very intimate exhibitions. There was the Sir John Soane House in London, where I worked for a year, the Barragán House in Mexico, and now the Lorca House in Granada. Poets and artists are invited to work there together.

Literature plays almost no role in today's art. Just as people don't speak of the Gesamtkunstwerk anymore. Both disappeared at roughly the same time, in the early 1990s.

It played a role from Surrealism to Fluxus.

Why this disappearance?

I think that this too has to do with acceleration and deceleration. Maybe it's because there's a lack of time for reading.

But I'm still thinking about your question of whether it's always just a time lag. Or whether there are things I categorically never publish. Yes, <u>there are all my videos—1,500 hours of filmed interviews</u>.

Do you write a diary?

Unfortunately, I have never had the time.

You're enthusiastic about the Merzbau and the Soane House. There something has come into being over a long period of time and in many layers. Do you as a curator also have the opportunity to initiate such a sustained process?

As a novelist, you work on a book for years. You rarely have this opportunity now as a curator. Architects don't have that kind of time anymore either. In the end, the ways in which Rem works and the way in which I work are very similar. In some way, we both have the longing to work exactly like a writer, but at the same time, we face an economic and logistical impossibility of doing this. In this sense, we have to circumvent this and find new systems so that it is nonetheless possible to produce knowledge. I cannot say that I want to do the interview marathon now. I'll work on it for two years. I can organize the one in London in two hectic months and then organize another one with Rem in Dubai a year later. Then a few weeks later, I can do do a sort of marathon about the metabolism at Documenta with *Archplus* and in Japan. That's how the marathon project creates sediment over the course of years as though I'd worked on it for years. Similarly, we are now once again organizing a Merzbau conference every six months at Cabaret Voltaire with Adrian Notz. We've now been working

on this for three years. The Robert Walser Museum, "Point d'ironie"—these are things that have been going on for ten years and often don't really go away even then, they just become a little less active. It's similar to an architect with several, very different construction projects.

You spoke of bulimia yesterday. Could it be that art used to be important to you and then suddenly you become sick of it?

No. On the one hand, I'm always looking for something new. It's the small country syndrome. When you are from a small country, you're often more driven towards other geographies, cultures, and contexts. At the same time, it happens very rarely that I drop things. I often work with people for ten, twenty years. Art is very rare. You create large group exhibitions and roundabout biennials, and not everything you do there is history. There are also things that have to do with an event, and for the moment it is very important to show them; there's energy there. But then at these large exhibitions you also find artists with whom you come to work with very closely. It is pretentious to say that I've never been wrong. Of course, you make mistakes and learn from them in order to make other mistakes, but when I reach this point after some time where I work very closely with someone, including in the big individual projects, then that is for a very long time. I've been working with Fischli/Weiss and Gerhard Richter for almost twenty years on many different projects.

What does the museum of the future look like to your mind?

I think that the museum of the twenty-first century is very complex. We are attempting to concentrate a great number of things at the Serpentine with Julia Peyton-Jones: there are the discursive things during the summer, there is the architecture, the pavilion, the public programs, and the book machine. Relatively many of our

ideas of how an institution works are being brought together within a small institution. And then you can, of course, start thinking that the goal may at some point be to set about creating a larger institution for the twenty-first century. Where there would also be Rothko chapels, i.e., small spaces. But there would also be more monumental spaces, time-dependent spaces, discursive spaces. In Victor Segalen's sense, an institution that produces shocks of difference. So from this perspective, you can say that all my projects are fragments that can at one point or another be brought together into one large institution.

You wouldn't be afraid that this would become the grand HUO Museum?

[laughs] It would have to be a museum that goes beyond this idea of being a personal museum. The museum can be a repository for time or a laboratory. And in the best course of events it is both. I think that this oxymoronic situation produces very interesting museums. The Pompidou, when it was under the direction of Pontus Hultén, is an example.

You just spoke of your skepticism regarding objects. Should the museum of the future itself even be an object at all? What about the Internet?

The Internet continues to play only a very small part in the art world.

In this case, is there an alliance between collectors, galleries, and museums, all of which have no special interest in it?

It will definitely come. After all, it also took a very long time until Nam June Paik made art with the television set. There's a time lag at work. The first moments are appearing. Delays are revolutions.

The Elephant Trunk in Dubai

*Art today is this gigantic trunk: it sucks the world in
and processes it into art. But the inverse influence art
exerts on the world is very small and rather decorative.
Will this change?*

I think that unlike during the 1990s, it is no longer suf-
ficient to infiltrate one reality or another; the point is
now instead to produce these realities. From infiltration
to engagement. I can describe this for my small field of
museums and exhibitions: in the early 1990s, the point
was, as in my project "Migrateurs," to infiltrate a large
museum like a virus. So that you would suddenly have
a kitchenette there by Rirkrit Tiravanija, and Félix
González-Torres would arrange flowers in the office.
Now, fifteen years later, the point is rather to invent an
institution. My big unrealized project that will become a
reality next year is a large exhibition about my archive
of unrealized projects.

And they will be realized in the exhibition?

Exactly. The idea is that the exhibition contributes
to the production of reality—and that many projects
will, thus, be realized bit by bit.

Art Center College of Design
Library
1700 Lida Street
Pasadena, Calif. 91103

The Postman Rings...

with Philippe Parreno and Alex Poots
London, The Gore Hotel, October 19, 2006

Hans Ulrich Obrist — Exhibition-making often has to do with ~~rules of the game~~. And one of the things that I have been discussing with Philippe Parreno, since we met each other about ten years ago, is an exhibition where if you do a group show you basically give an artist space. ~~What would happen if you had a situation where actually each artist would not get space, but time?~~ And so that is the point of departure. And through a dialogue with the Manchester International Festival —where everything is new—there was a possibility for the first time to actually realize this. The strange thing is that, as simple as it seems—as basic as it seems—there doesn't seem to have been a group show so far which has followed this "~~rule of the game~~." In this sense it is a niche, almost like a loophole in exhibition history—we feel that this is a very urgent loophole of something that has not yet been covered.

Philippe Parreno — *Shall we address the issue of the title? "Il Tempo del Postino"** is based on a text that I wrote in 1992 called "Postman Time," which addressed the issue of how long you take to look at an artwork and who decides the time involved in the reading, in the experience of an artwork. "Postman Time" is a word play: in French, the postman is called* le facteur*, hence, "factor" time. So the idea will be to create these scenarios where artists will address this directly. Not addressing the space they occupy but putting their work into a time-based protocol. So for the past ten years, the discussion repeatedly came up about this possibility of a group show based on the idea of the audience journeying through a museum without moving. The feeling of art comes to the audience, rather than them going through the space.*

I think the idea of the libretto has been important.

* Participating artists: Doug Aitken, Matthew Barney & Jonathan Bepler, Tacita Dean, Trisha Donnelly, Olafur Eliasson, Liam Gillick, Dominique Gonzalez-Foerster, Douglas Gordon, Carsten Höller, Pierre Huyghe, Koo Jeong-A, Philippe Parreno, Anri Sala, Tino Sehgal, Rirkrit Tiravanija & Arto Lindsay

What remains from the group show?

Yes, what remains from the exhibition? There are several layers to this question. We have worked with the Vienna Opera [www.mip.at] and I have always felt that it is stunning to which extent opera started to produce music. You can see how, a hundred years ago, the opera produced a lot of music to add to the repertoire. Slowly, fewer and fewer new things were produced. We thought it could be interesting to follow this idea with an exhibition that can enter the repertoire. There has to be a libretto. So beyond the question of an object, an exhibition can be reenacted or restaged. When we are all dead in a hundred years, this group show "Il Tempo del Postino" can be staged in Sydney or New York or London by a completely new generation. It is repetition and difference—which raises this question of the score. Cage spoke of the open score.

And then we met with Pierre Boulez ...

That was a crucial moment.

I met Pierre Boulez with Hans, as part of the research for this project. One of the questions we posed to him was about this idea—how is it that the scores that he has written have not really been played very often by anyone other than him? And he answered with this notion that really addressed a lot of postmodern production, which we have all been involved in, that you can buy the scores of any opera or music that he has composed, but what is missing is "the score, the score"—which is the difficulty, the missing elements that people need in order to play the music. This is his problem as a contemporary musician, but this can also definitely be applied to the context of the exhibition. Which means, you can set up a group exhibition, but then how do you replay it? How do you restage it? Of course, you can have a list of the artists and the works you decide to exhibit, but still there is a missing element which makes the show into that thing which is unspoken, an experience or not, or as Boulez defined it: "the score, the score."

He also called it the "infinite score"—the score is not finished ...

Alex Poots — *Ever evolving ...*

Yes, and so in this sense, it is not a finite group show; it may well be that after it has happened in Manchester, it will eventually travel to other venues.

It can be played by anybody committed enough to see it again. So what we talked about earlier was the idea of giving the score, the libretto, to kids. Kids could spend a year restaging the project. The performance project of Douglas Gordon, performed by Jessye Norman, could be performed by a schoolchild singer in the dark and each proposal could be done like that. I see that as a crucial element: to see if we can have that action, the libretto, being restaged by, in that case, kids. It's basically a subtext for this exhibition.

There is another aspect we need to cover: with this group show, it could not function if we were to ask an artist to illustrate an idea. The exhibition only works because there is a shared desire of the artists involved to produce this sort of momentum. This has a lot to do with the fact that it is no longer mediated through film—~~one of the rules of the game~~, which we have collaboratively worked out, states that there is no film and no video. This is an important thing. Many of the artists of our generation, and even more since 2000, have used film as a form of mediation. It's very interesting that Matthew Barney pointed this out. We had an infinite evening at Pelham with Matthew, Olafur, and Douglas in London last year—we just couldn't stop talking until 6 a.m. or something. And Matthew said that he had been doing so many films with the Cremaster—and it doesn't matter who said it, as everybody had this shared feeling—that it is now again more interesting to do something live, something which is not mediated.

Yes. The open stage offers the chance to address a direct experience of an event without sub-media.

> *I'm interested, Philippe, you co-curated this project with Hans, but you are also directing it. After bringing together this amazing group of artists, who are mostly of the same generation, how do you see this piece coming together as a whole?*

At some point, there is a need for direction, a need for more than a series of tableaux on stage, more than a series of events. In a way, people go through a journey. The way we are going to knit—and it's also a self-construction with things naturally falling before or after one another—but there is still a need to create architecture which is based on time.

> *Is it too soon to ask—do you have ideas as to how you are going to do that?*

Yes, a bit soon, as we don't have all of the projects on paper yet. Through the discussion we had with Darius Khondji, who is going to do the lighting, or with James Chinlund, the art director (both from the movie world), we tried to address this issue of putting stills next to each other—there is this feeling that seeps through the different performances. So how are we going to address that? Will it be melancholic? There is a mood that will come, with a rhythm, and that is why I'm interested in the show as a group show; there is a sub-text we are looking for. What will be like the musical idea of a generation, there is something beyond words that will echo through the different performances, and that is— in a way—what I'm looking for.

Do you mean post-symbolic?

Yes, post-symbolic.

> *So, it's not a literal narrative, an emotional narrative.*

Yes, so something that links different practices to each other that are formally really extreme; for example, between Matthew Barney and Liam Gillick there is a big difference in forms, but also something that remains similar. They are quite extreme in the spectrum of contemporary art, and so what we are now trying to address through the direction is: What is the drive that makes these people commit to the same project?

And do you have any sense of what the answer to that question is?

My guess is that music will address that issue.

Is there a shared consciousness?

There is something about the consciousness of addressing forms, and being conscious about it.

I remember you once said that fifteen years ago none of you would have touched time, but now you feel ready to do that. It interested me that this project is of its time.

Not only time, but also the performance aspect itself of each work: to actually come on stage without protection, and expose yourself.

Why do you feel more able to do that now than maybe ten years ago?

Part of it, I think, is being more conscious of one's practice, but also more than that, we are ready now to share it. The conversation that we had that night, with Matthew and Olafur, Douglas and Liam, was completely relevant to that—the need to share things that we never had time to address. This is an open stage scenario, where everything can be strong and discussed from the beginning because there is no architecture —a bit like a self-constructed space that you build up with your desires to see something coming. So the shape is not focused yet, and every time a proposal comes in, the discussions

we have had define it a bit more—that mysterious, weird shape that we start to see or touch, but is not clear yet.

> *I don't know if this is present in this project, but it seems true of other artists whom we are working with at the festival, there is this thinking that actually there is so much you can do on your own as an artist. And that the Hegelian idea of thesis, antithesis, greater level of synthesis is now very much of our time. And I wonder if that had any relevance to your thinking about this show.*

There is definitely something in that. Also in one of the theoretical approaches we have discussed—Hans' Bachian polyphony and dialogism—this idea of how you can start to be responsible for somebody else. So there is a trust, partly because it's Hans and it's me, so people are willing to let it go, in order to see what is coming back again. So there is something about that, in a way, which makes people a little freer to be a bit less secure and more open-minded, throw out ideas and see the ways they can bounce back and find their shape again. Many of the projects we had at the beginning have changed quite a lot since the first discussion we had with the artists, and it will change again until the end. And each project gets reformulated also, by knowing what the others are going to do—because we played this game where we send the proposals back and forth from everybody to everybody.

> *Just once more, to help us, can you talk about the beauty and the metaphor of the title?*

It's also—what did Peter Saville say? He said, the postman is someone who comes to your place, appearing to deliver a message.

> *Yes, a deliverer of messages. Someone is giving you something. It's a gift.*

But also you were saying that, rather than walking through the exhibition, it is delivered to you.

> *The exhibition is delivered to you, so the idea is that you're not walking through a gallery.*

It's like a walk through a museum or exhibition without moving. There is also a scene in a film that starts with the postman delivering a telegram, and then the movie starts. That scene was also important. The postman comes, and then the journey starts.

But I want to say that there is one thing we haven't spoken about: one thing that is crucial is that this project follows right after Philippe and Douglas did *Zidane,* a feature a feature film they produced, which is fully recognized and acknowledged in many countries by the film press to be a major film and work of art. And so after having ventured into cinema, what we have here is the first time that a contemporary art project will tour through the major opera houses in Europe and then maybe New York (though, of course, theater X and opera Y have often commissioned an artist to do something). In a way, it's related to the idea of *Zidane* and many other projects of the last couple of years, but in the 1990s it was only a sketch, and now it is a reality.

A Mad Dinner in Reagan's War Room

with Brendan McGetrick
August 10, 2007

Brendan McGetrick — *What is the motivation behind your interviews?*

Hans Ulrich Obrist — One could say that there are parallel realities: on the one hand, there is the curating of exhibitions—my main work is curating—but I've always had a sort of parallel activity, which is my research and knowledge production—and that's the interview project.

The interview project actually predates anything else I'm doing, ~~because everything started with conversations~~. Whenever I do exhibitions and books, they are the outcome of such conversations—conversations with artists, architects, scientists, all kinds of practitioners. So, one can basically say that the conversations are not conversations for conversation's sake, but are always working conversations. I'm always working with these artists, architects, or scientists, either on a show or on a conference or a book, and very often the conversation is not only parallel to working on a project, but new projects even grow out of the conversations. So, one can actually call them "production of reality conversations."

What references or models do you use to process their partic-ular methods of producing reality?

There are different layers to it, I would say. I've always been obsessed with art, and my home base is clearly the art world. However, in the early 1990s, I started to work with Kasper König at the Städelschule; and I met Dara Birnbaum and Dan Graham, who kept telling me that I should read *Learning from Las Vegas* and *Delirious New York*. At that time in Frankfurt, there were architects like Enrique Miralles, Peter Cook, and Cedric Price. For me, these were all very urgent encounters, because I didn't really know much about architecture at the time.

In the very beginning, it was also a pragmatic thing. When you're a curator, it's interesting to involve archi-tects in the exhibition design, because exhibitions that

<u>don't have an inventive display feature are doomed to oblivion</u>. So you can have either an artist or an architect invent your display feature. While working with Kasper König, who had done shows like "Westkunst" and "von hier aus," I was very inspired by the idea that he had often invited an architect to invent the display feature.

That's why in all my shows during the 1990s, from "Cities on the Move," which we did with Hou Hanru, where we had first Chang Yung Ho, then Rem Koolhaas with Ole Scheeren, and then Shigeru Ban; to "La Ville, le Jardin, la Memoire" (co-curated with Laurence Bossé and Carolyn Christov-Bakargiev), where we presented Zaha Hadid's installation; to "Mutations" (co-curated by Rem Koolhaas, Stefano Boeri, Sanford Kwinter, and Nadia Tazi), for which Jean Nouvel and then Kazuyo Sejima developed an exhibition design; to shows like "Laboratorium" (co-curated with Barbara Vanderlinden), where we invited the artist Michel François to do the exhibition design, or Zaha Hadid, who reinvented the park at Villa Medici for our show. And Kazuyo Sejima did the exhibition design for our show "Mutations" in Tokyo. Jean Nouvel did the exhibition design in Bordeaux.

How did your involvement with architects expand from this first, pragmatic layer?

With "Cities on the Move," it became something else, because at that moment, we felt it was important to do an exhibition on Asian cities, and we realized it should not be just representing cities, but more like imagining a city as a performative space. <u>The idea was really to develop the exhibition as a city</u>.

So, we invited a lot of architects and artists working in these Asian metropolises. In the beginning, the architects sent in lots of architecture maquettes. But little by little they realized, because the show was touring, that it was a laboratory, and that it might be

more interesting to actually experiment with the format of the exhibition than to just send a maquette. With time, these laboratories of "Cities on the Move" negotiated a new way of involving architecture in exhibitions. So the architects' presence was a second layer in my exhibition.

A very close friendship with Rem Koolhaas grew out of "Cities on the Move," and that was sort of a third layer. Since we began speaking regularly, we realized that, early in his work, Rem also had an interview practice—he had interviewed Constant, Salvador Dalí, and many others. And we thought it might be interesting to do some interviews together.

We started to visit pioneers or architects who were important to my research and who were important for Rem in the 1960s. So we went to see Venturi & Scott Brown, Philip Johnson, and most recently Christopher Alexander, O.M. Ungers, and all the Metabolists in Japan.

Do you consider the 24-hour-marathon interviews that you've been doing with Rem Koolhaas an extension of this?

Within my practice of exhibitions, there is always a way of working with formats, inventing new formats. But conferences usually don't have that dimension because a conference or symposium is a kind of boring routine: there's a talk, there's a panel, a Q & A, then the moderator is running out of time, and then, maybe, a dinner in a restaurant.

The question was really: Can my experiences from exhibition-making, which is an obsession with new formats, be transplanted into the world of lectures and symposiums? So we did a [interview] marathon with Rem at the Serpentine Gallery. We interviewed for twenty-four hours [straight], seventy practitioners to make a kind of portrait of London. We just did another one in Germany this Sunday [at Documenta], and we did one in Cagliari and in Dubai.

That leads us to a fourth dimension, which is obviously the idea of building architecture. That is a more recent

experience, because after arriving at the Serpentine last year as Co-director of Exhibitions and Director of International Projects, I began working with Julia Peyton-Jones. As director of the Serpentine, Julia initiated a visionary groundbreaking pavilion concept, where she showed that a small art institution can be an important client for architecture by building temporary pavilions.

She invited Zaha Hadid in 2000, then Toyo Ito, Daniel Libeskind, and many others to build a pavilion in the park in front of the gallery. So, when I arrived last year, that was an ongoing project, and Julia and I thought we'd invite Rem together with Cecil Balmond to do this pavilion, which really became a structure for conversations. As Rem said, "Buildings without content are meaningless shapes."

In relation to visiting these pioneers, what do you feel is the importance of memory in your work?

To some extent, within my own field, which is the world of art, there is a very strong emphasis on memory but not in a static way. As neuroscience shows, memory is a very dynamic process in the brain—and I think [dynamic memory] is a particularly interesting topic in China now.

Given the staggering amnesia in the world, I think the idea of memory as a ~~protest against forgetting~~ is incredibly important. The art world has a mechanism which is quite elaborate that encourages artists to talk about older artists and forgotten artists. Obviously, there are always artists who are forgotten, but in the art world, artists from the 1960s and 1970s and 1980s are regularly being re-discovered. Every ten years, one looks back again, and sees what's been forgotten.

That works through a mechanism where artists talk about older artists who've inspired them, as well as through the multiplicity of museums, because nowadays, every small city has a Kunsthalle and a contemporary art museum. So there are literally hundreds, if not thousands,

of contemporary art museums, and that makes it a given that there is some sort of memory work going on. But coming from art, <u>I was surprised by a certain lack of memory in the architecture world</u>.

I met people who were for me great inspirations, like Cedric Price, Yona Friedman, and Oskar Hansen, in the 1990s. From them I learned a lot for my own practice as a curator, through their questioning of the master plan ever since the late 1950s. Self-organization is something which curating had never really adopted. In French you even call the curator a *commissaire* [commissar], which is police vocabulary really, and so you, as a curator, always have this authoritarian role of drafting a checklist—who is in, who is out, and all of that stuff. With regard to Yona Friedman and Cedric, I thought about how one could adopt these almost cybernetic ideas of complex, dynamic systems with feedback loops and self-organization into the context of a larger show?

I tried to do this with almost all my shows in the 1990s—"do it" or "Cities on the Move" or "life/live" or more recently, "Utopia Station," which all have a high degree of self-organization. And so, ~~being inspired by people like Cedric Price and Yona Friedman, I was somehow staggered by the fact that in the architecture world there are not really these mechanisms of memory~~. Particularly in the mid-1990s, someone like Yona Friedman was completely forgotten. There was hardly any literature around, and so the art world became a sort of refuge where these pioneering architects could be rediscovered. So, we've organized dozens of exhibitions with all these people. Many other people have done that too; I'm not the only one. It's been a very collective effort.

What accounts for the lack of memory in architecture?

It probably has to do with the fact that there are far fewer good architecture museums than there are art museums.

It's interesting that it takes a long time before a building becomes a collectible item. Now, people have started to collect buildings for very large sums of money, but that's three, four, five decades later. And it's interesting that at the moment there's a booming art market and design market, but there is no market for architecture yet.

People of Yona Friedman's generation have extraordinary archives, and it's very difficult to find museums that can actually secure these archives for posterity. So, I think that's maybe the fifth dimension of my project — ~~the idea of a protest against forgetting~~.

What other forms of protest does your work involve?

I think the idea of ~~going against the fear of pooling knowledge~~ has always been key for me. Going back to my beginnings when I was working with Kasper König, I had the experience of being in a small school—where an art school and an architecture school were together —and I think it's a great pity to separate art from architecture schools, because these encounters have been most productive.

Had I not been in the Städelschule in 1991, and had I not met Enrique Miralles, I might never have been immersed in architecture to this extent. But you can go even further back in history and take an example like Black Mountain College, which was key for postwar art in America. There you also had a link between poetry and architecture; Buckminster Fuller came to do seminars. So for the future of schools, I think it is super important that art and architecture are brought back together.

In the context of advocating a reconnection between art, architecture, and other disciplines in the academic world, what are your thoughts on the way in which architecture has been drawn into a larger concept of "design," mostly through the intentions and instruments of the free market?

To some extent, what is interesting about these collaborations and dialogues is that they don't necessarily have to fulfill a demand—that can come in a second stage —but there has to be an inner necessity in order for these dialogues to happen.

At the end of the day, it has everything to do with these sparks that happen in schools as beginnings. If you speak to Brian Eno, he went to art school and got a spark there and then went into music. Things are very often not so linear, and <u>right now schools are becoming so target-oriented: immediately someone goes into architecture to become an architect. That's why I believe in the type of school where the unpredictability of nonlinearity is allowed to happen</u>.

But I think there is a moment right now where art, architecture ... and design have converged. The danger is always that there is a consumerism of difference within them. It's sort of a nightmare that everything will be "design." So I think it's extremely important that, within these negotiations and dialogues, difference is maintained.

Édouard Glissant has always emphasized that in our current form of globalization there are very strong forces of homogenization, and the question is how to resist these forces and develop models where difference is maintained and where we can find ways of actually increasing difference within the global dialogue. In other words, on one hand, not to refuse the global dialogue, which would be local atavism, and on the other, not to embrace globalization blindly, but to negotiate a global dialogue—he calls it *mondialité*—which produces difference.

That means that there are lots of new regions and new possibilities, but it also means that there is a point of view from which you start. I think it's extremely important that there is an art world, that there is an architecture world, that there is a design world, and then it becomes more and more possible that these worlds create parallel realities.

But maintaining these differences and constructing these parallel realities would seem to imply actively resisting the expectations of the market and globalization, wouldn't it?

That's why I think the idea of nonapplicable models remains so important. The danger, obviously, of it all becoming about design is that it all becomes about an applicable model. If you think about Piet Mondrian ... [the work of] Piet Mondrian is a nonapplicable model, and I think it is incredibly important that, in the twenty-first century, we continue to strongly investigate non-applicable models.

I've always felt that in China today there is a sort of similar situation happening like in the West during the 1950s and '60s and in Japan before the Osaka World Fair in the late 1960s and early '70s—there is an incredibly exciting dialogue between artists and architects and designers and so on.

For instance, if one looks at the practice of Wang Jianwei, he collaborates with theater people and with architects. Clearly, he's a visual artist, but he forms all kinds of bridges. Or if you look at Ai Weiwei and his parallel realities: he is one of the leading visual artists, but also a leading architect.

<u>In China, more and more architects and artists are working together on buildings, and Ai Weiwei is a driving force—he goes beyond the fear of pooling knowledge</u>. <u>It's in the West where the artist is invited only at the very end for a "one percent decoration" of an already existing building</u>. Often artists are involved very early on in China, and there is a true art-architecture collaboration.

The problem is that it's become the fashionable in Europe to work with China—every museum wants to have a China show—but I don't think that's interesting right now. What I think is interesting is that we have a situation—and it's very much like what Fernand Braudel describes in the fifteenth and sixteenth centuries—when seismic shifts start happening and all of a sudden

the centers of gravity are shifting. It's long-distance running!

~~The fifteenth and sixteenth centuries marked the shift in gravity from the Mediterranean to the Atlantic~~. And now it's definitely these new centers in China, India, and the Middle East that are so powerful. And working in Western European institutions, one of the great and urgent things to be done in the early twenty-first century is to show and map out platforms for these extraordinary seismic shifts.

The idea of a nonapplicable model is interesting in the Chinese context, because often there is a strong sense of practicality and usefulness that can make things more interesting but can also limit nonapplicable projects.

To some extent, one of the great strengths of art has been that it proposes a nonapplicable model that may be an applicable model in very different times. It's the idea of, in some way, resisting an immediate consumption and applicability. And I think that's also why artists with more complex work, usually in the long run, are much more important and have a bigger resonance than artists who propose logos. And obviously a lot of Chinese art, ever since the 1990s, has been about providing easily recognizable logos for the Western market.

<u>In the long run, the more complex artists win. Whenever I'm in China and I speak to the youngest artists, I say, "Who is your hero?" And so many say Huang Yong Ping. But it's interesting, because Huang Yong Ping is an artist who has continued to work with very complex, unpredictable content</u>, which will take us another twenty years probably to understand. So I think he is a great example for those models that are not immediately applicable but continue to resonate. And the same is actually true for architecture, even more so. And I think there are important examples of this in Chinese art.

In talking about the importance of memory against the forget-fulness of the current moment, many forgotten heroes that you mentioned, Cedric Price, Yona Friedman, etc., were masters of the nonapplicable model. Do you think there's a connection between the unwillingness to look at the past and the unwilling-ness to look at the future in a visionary, nonapplicable way?

At a certain moment, Cedric Price, in the context of James Lee Byars World Question Center, was wondering why it was so difficult in industrial—now post-industrial—Western society to make useful mistakes. And to some extent, <u>as Qingyun Ma pointed out to me, in China the idea of failure has a more positive notion</u>. So perhaps, if it was translated, the writing of Cedric Price could find a great resonance in China.

I think it's a possibility of an impossibility to, on the one hand, actually build, while on the other, contribute to the history of ideas and change the course of things. That has a lot do with writing and books.

It's interesting because you're doing this conversation for a book by an architect who invents the book as a new format. Because this is a very unusual book, it's an unu-sual conversation. There are too many coffee table books about architecture. I think, to some extent, a maximum degree of redundancy has been reached. I cannot see another coffee table book with all the projects of an architect published in it—particularly if they are very heavy. However, what is so fascinating about architecture is that architects sometimes succeed in using the book as a medium in their practice, and that's something that Corbusier was the master of. The early books of Christopher Alexander are another example of when books of architec-ture become something not just about the work, but media through which one can enter the history of ideas.

You seem to be identifying two poles—built architecture and theoretical architecture manifest in book form. Are the Serpentine pavilions an attempt at a middle ground, through temporary, experimental architecture?

I think the most underrated aspects of architecture's presence are pavilions and exhibition design. These are two things that we've talked about a lot in this conversation, which are obviously, for me as curator, the two key forms of producing reality in terms of architecture. This doesn't exclude future movement elsewhere and beyond, because, being interested in the production of reality, I'm more and more interested in the idea that an exhibition is actually a city. After doing "Cities on the Move," one can imagine curating and urbanism being more intertwined, but that's the future: <u>building a new city as a curatorial project</u>. What's interesting is that these ephemeral, nonpermanent architectures throughout history have very often created a lasting effect and contributed to the discourse of architecture. So, it's not that if a building is permanent, then it's historically more important.

Examples like Alvar Aalto's pavilion for the [1939] World's Fair in New York or, obviously, Mies's Barcelona Pavilion. Beatriz Colomina wrote about the idea of the pavilion of the future, in which she showed us Alison and Peter Smithson's House of the Future, Corbusier's L'Esprit Nouveau pavilion from 1925, the "Parallel of Life and Art" exhibition at the ICA in 1953, Bruno Taut's Glass House from 1914, Mies van der Rohe's Barcelona Pavilion from 1929, or even a more recent example, Aldo Rossi's 1970 Teatro de Mundo.

As Colomina shows, all of these are ephemeral structures that are as much part of the history of architecture as permanent buildings are. They become part of the canon and push the envelope of what architecture can be.

I think this idea is also true for exhibitions. Colomina says, "Exhibition pavilions in the twentieth century acted as sites for the incubation of new forms of architecture that were sometimes so shockingly original and so new that they were not even recognized as architecture at all." She refers then to Mies's Barcelona Pavilion, which is now understood as one of the most influential buildings of the last century, but it was actually seen by hardly anyone.

Recently, I interviewed the visionary Ken Adam, who is one of the key set designers of cinema history. For me, Ken Adam is one of the great architects of the twentieth century: he designed many James Bond movies, but he also designed many of the key movies of Stanley Kubrick, such as the famous war room in *Dr. Strangelove*, a room which is as present in many of our minds as many permanent buildings—probably more present. There's this famous story that, when Ronald Reagan was elected into the White House, he arrived on the first day and was completely lost because he couldn't find the war room. He had taken it for real. So, out of this anecdote, we can conclude for sure that Ken Adam has produced some form of reality, and even if that stage set vanished a long time ago, it's going to exist forever.

Pavilions can also last forever in memory, but this is also because pavilions can be rebuilt. The Barcelona Pavilion is an example of this. It's also potentially possible for the Serpentine pavilions; in the future they could be rebuilt or restaged. However, they are *a priori* ephemeral.

The most underrated part remains exhibition design, because still you don't find any books or images in architecture catalogues; economically it is not interesting, it's not a big industry. Exhibition designs are sites for the incubation of new forms of architecture because they are, to some extent, very low-budget operations. Exhibitions usually don't have big budgets and usually ask for a very high degree of improvisation, but it is in these contexts that very often a great invention is made. If you think about Alvar Aalto's exhibition for the pavilion of the World's Fair in New York, he developed this undulating surface. When I saw an Aalto retrospective designed by Shigeru Ban the other day, there was this point when I realized that his idea had influenced so many architects —and it's just a simple, ephemeral exhibition design that Aalto had invented for an exhibition.

In the virtual world, for example Second Life, people are building their own world and relationships through

semi-architectural means. What's your impression of virtual art and architecture as perhaps an even more ephemeral means of expression?

Rem Koolhaas and I just conducted this interview marathon in Germany, and we interviewed generations of German architects from Gottfried Böhm, who's in his late eighties, to much younger architects, like Jürgen Mayer H. And one of the things that acted like an umbilical cord throughout these conversations was the idea that it is not a question of either virtual or actual, but how the two are intertwined. Take the town hall that Jürgen Mayer H. designed in Germany, for example. All of a sudden the town hall no longer has the functions it used to, because most of them have become digital —people vote digitally, people no longer come to the office for all these things, they'll soon probably order their passports digitally. So all of a sudden the whole dynamic of a town hall completely changed. One can no longer separate one from the other because there is this huge digital building there, which is a town hall, but then there is also a physically built building.

I think also, to some extent, it is interesting to think about in relation to television. When television was invented, obviously radio had to be reinvented, but it took a long time from the invention of television until a great artwork was created with this new medium —probably not until Nam June Paik. And now, even if there are very interesting initiatives happening in terms of virtual reality artworks and all of that, <u>I have yet to see the "Nam June Paik of virtual reality."</u> I'm sure that his or her arrival is imminent—no doubt, whatsoever. But it usually takes a little bit of time from the moment a medium is invented until the moment a great artist or architect makes a great piece with it. Maybe it happens in Second Life! Cao Fei has developed an amazing work called RMB City—a virtual reality city located in Second Life, a city that produces an online art community and platform for production of reality.

The Enemies Are Those Audio Guides

with Jefferson Hack
February 2007

⁂

A conversation with Hans Ulrich Obrist has infinite and frenetic possibilities. Rem Koolhaas once said that the omnipresent Swiss-born curator and irrepressible interrogator left his native country because the way he talked was too fast for the Swiss. Here is a man who has made conversation itself into an art form, who has a ravenous appetite for his subjects, and an uncanny knack for teasing out those sparkling and unexpected details, raw and uncensored. Obrist has cornered and interviewed an ever-expanding spectrum of the great and the good as they cross his path, from architects to linguists, philosophers, scientists, filmmakers, and musicians, compiling a kind of ongoing Smithsonian Institute for the state of aesthetic thought in the twenty-first century. Entering the art world from a background of economics and politics, his curatorial eye has transformed the possibilities of the white-walled gallery. A penchant for a radical choice of venue—his own kitchen, airplane cabins, a monastery library, a sewage treatment plant, a vitrine in a restaurant in the Swiss Alps, as well as an online exhibition helping viewers to perform artists' works on their own—has showcased a playful ability to relinquish control in pursuit of an altogether nonlinear experience. He is currently bringing his considerable experience to bear as Co-director of Exhibitions and Programs, and Director of International Projects at the Serpentine Gallery, where over ten years ago he once curated a jumble sale of a show, where visitors were invited to take home the exhibits.

⁂

Jefferson Hack — *I'll put this recorder closer to you so we can be conscious of it.*

Hans Ulrich Obrist — Okay.

Let's talk about the conversations. They are not set up to be formal interviews, are they?

I think that's why sustained conversations like these are so interesting. For me, the inspiration was David Sylvester. I began to be interested in conversations with artists because of an incredible book he did with Francis Bacon. Whenever he met Francis Bacon, he recorded the conversation. And little by little they became this incredible book, which, as a kid, I read again and again. That's what pulled me into art.

What do you feel you get out of sustained dialogue and the conversations that's different from an interview?

I think it has a lot to do with the changing of locations. I've just done this conversation with Jeff Koons for *Paradis* magazine. Each time I called him he was in a different place. But then there is also the traveling together. I've done many really long interviews with artists on airplanes. Pierre Huyghe and I recorded during a whole flight from New York nonstop to Paris. Also traveling with Anri Sala and Philippe Parreno through Europe.

Were they happy to cooperate or did they just want to get some sleep?

[laughing] Oh no, they were happy.

Just checking ...

Early on, in one of my first interviews, <u>Christian Boltanski pointed out to me that the danger of interviews is that</u>

we always say the same thing. Often ~~new rules of the~~
~~game~~ trigger new conversation and new content.

People do tend to repeat themselves.

In 1991, when I was just starting out and still doing
shows in my kitchen, I started to become interested in
artists' writings ... like the writings by the great artists
of the twentieth century, from Henri Matisse to Gerhard
Richter to Richard Hamilton. So I started to realize
that if these books weren't out there, then I would have
to edit them and get them out there myself.

You did a book with Louise Bourgeois?

I edited the writings of Louise Bourgeois, Gerhard
Richter, Gilbert & George, Maria Lassnig, Leon Golub,
and now a book on the writings of John Baldessari.
 It is so interesting going through artists' archives.
I've obviously gone through all the interviews that
they've given over the years, and there are very often
similar questions being asked or similar issues being
covered. And I think that's what's so interesting about
sustained interviews because one gets away from the
risk of repetition.

*Is this your fight against cultural amnesia? Is that the differ-
ence then; it's not just about recording history, it's also about
making history?*

Yes. For me, the most urgent part of ~~the whole conver-~~
~~sation project is the idea of the production of reality~~,
which leads to my fascination with "~~unrealized projects~~"
—it's basically the only recurring question in all of my
interviews. Architects always talk about their ~~unreal-~~
~~ized projects~~; that's how they produce reality. They
publish their unrealized projects in magazines,
they publish them in books, they publish them all over the
world. And after a long time, what is at first considered

to be un-buildable, finally gets built. There are fantastic examples from visionary architects like Zaha Hadid. She has actually really changed history because her projects were always considered too utopic, but now they are built all over the world. What's interesting is that the art world never really looks into unrealized projects; the architects do, but not the art world. Or the music world. I mean most of the musicians and composers I've talked to have been surprised by my question: "What is your utopia? What is your unrealized record?" They're not asked that very often. But there are all these projects artists would like to do, which they can't. And then there's also this whole idea of self-censorship, books you wouldn't write because you fear they may be censored—particularly if you work in a undemocratic environment. Or projects are too big, or too small to be realized. Or self-censored projects.

Okay let's flip the question: What is an unrealized dream for you?

Oh yeah, okay...

Not so much an unrealized project but an unrealized dream?

First, to do a big exhibition on unrealized projects. But there are many. My other biggest ~~unrealized dream is an art institution for the twenty-first century, which would combine all these experiences I've been working on so far. A big art institution~~ ...
 My dream is to realize the dream of Cedric Price, who once told me, "A twenty-first century museum/art center will utilize calculated uncertainty and conscious incompleteness to produce a catalyst for invigorating change whilst always producing the harvest of the quiet eye."

Where would it be based?

It could be anywhere. It has a lot to do with my discussions with Cedric Price about the unrealized Fun Palace. It's somewhere between the Crystal Palace, the Fun Palace, The Palace of Unbuilt Roads, The Rothko Chapel, an archive, and a laboratory.

The Fun Palace?

It was an idea Cedric Price and the theater director John Littlewood came up with in London in the 1960s. A totally transdisciplinary institution. One of the big dreams is to talk to Godard ... but that has never really worked out!

Why is that?

It's difficult to set up. It might happen one day.

That would be amazing. I read in your book ...dontstop-dontstopdontstopdontstop that you think art institutions are obsessed with big names, and what's more interesting to you is promoting what is happening now. Now you're saying the art world is too obsessed with the now. You are looking at people who have been marginalized or passed over, who are just unfashionable in a way.

The new relates to memory and ~~I think memory is a profoundly dynamic process~~. It's necessary as a curator to look at emerging new artists and to also look at all these geographies and new cities. The world has changed so much since the 1990s—now, we no longer have five cities, but dozens of art centers in Europe alone. Reykjavik and Oslo are suddenly very dynamic. Berlin is being revived because so many artists are moving there. Brussels is on the move and there are also places like Warsaw. My first lecture, when I was still curating from my kitchen, was in Glasgow.

Is that where you met Douglas Gordon?

Yes. Douglas Gordon told me about art being a pretext for a conversation and the promiscuity of collaboration. The Glasgow Miracle! And in China it's not only about Shanghai, or Beijing, but there's also this amazing thing happening in Guangzhou, which is so dynamic. And in America, it's not just New York, but it's Los Angeles, Miami, and Portland, where we saw the emergence of amazing people like Miranda July.

You're spending a lot of time in London at the moment. Why do you find London interesting?

I think in some way it's much more global than when I last lived here. There are many more people from all over the world living and working here now. It's become like New York. No artist really belongs to any city. Artists live in Berlin, and they exhibit in London and New York, and in some kind of way that's a really interesting development. I've spent so much time discussing with my friends where we should live. At the end of the day, maybe it's the wrong question. For me right now, London is where I spend most of my time. London is where I work, it's where I spend my week. And then Berlin is where I write. <u>We all find our own perceptive band</u>.

Speed is something that I wanted to talk to you about. Do you feel that you are too fast for the world you live in? Like the world is naturally too slow for you? Do you feel comfortable with the speed at which things are changing or do you feel alienated or confused by it?

In a way, I think it is just a condition we live in.

You accept it?

I think the question is how we can differentiate. <u>It's very important to inject experiences of slowness, so I think curating exhibitions is also about having slow lanes</u>

—<u>not only fast lanes</u>. I think it's very interesting what you said about things being prescribed because in museums and exhibitions now, <u>the enemies are those audio guides</u>. I went to see an exhibition where I wasn't able to return to a painting because there were thousands and thousands of people there with those audio guides. They're already a nightmare, advancing, advancing from painting to painting. And the beauty of an exhibition is that it's a nonlinear experience, so you can return to a painting. Pictures don't reveal themselves instantly; it's important to be able to return. I love, you know, T. J. Clark's new book, *The Sight of Death: An Experiment in Art Writing.* In it he describes a residency at the Getty; he would always return every morning to the same two paintings by Poussin, not really knowing where he would end up. And that's the whole idea: having nothing special on his mind, he was just looking.

Are those notes you're writing? Are they to do with the conversation or are they notes for later?

It's to do with the conversation. I always draw these diagrams. It's a nonlinear rendering of the conversation.

Something Is Missing

(for Lucius Burckhardt)
with Juri Steiner
2006

Juri Steiner — *How was your interview with Constant?*

Hans Ulrich Obrist — There was this little dog running through the studio, a place full of fragments of a painter's life. Constant spoke of his break with Debord and how the movement, starting with playful Lettrism, had become more and more political, and a lot about the visionary New Babylon project, the idea of which was to liberate residents from their prison of identity.

And you never interviewed any other Situationists?

Not directly. Most of them have been dead for a long time. But for the interview marathon project, such an interview came about, so to speak, in the spirit of Situationism. In London, we had gathered together a whole crowd of people. At some time or other, Rem Koolhaas remarked that it was incredible that the point of reference that was often mentioned during the twenty-four hours and over seventy interviews was Situationism.

Now, apart from Paris, London is probably one of the most Situationist cities, and also the birthplace, thanks to Ralph Rumney, of psychogeography. This influence emanates right up to present-day positions, e.g. Payne & Relph or the films of Patrick Keiller. It's really quite strange: I am sitting here in London telling you about the Serpentine interview marathon and all its Situationist reminiscences, while you're sitting in Zurich.[1] We thus have the coordinates London-Switzerland. And so, against the background of Situationism, we should really dedicate the interview to Lucius Burckhardt from Basel. After all, he is one of the great pioneers of psychogeography.

And in terms of the Paris-London axis, you would shift the importance in the direction of London?

1. See also "In Conversation with Raoul Vaneigem," interview by Hans Ulrich Obrist, *e-flux journal*, no. 6 (January 2010), http://www.e-flux.com/journal/view/62.

It's rather a polyphony of cities. Paris of the 1950s is the starting point for Lettrism. But it is important to look at Blake, De Quincey, Baudelaire, Benjamin, and so you quickly strike the roots in literary London. One could say that Daniel Defoe wrote psychogeographic reports.

A few years ago, Iain Sinclair made a connection between Blake and Situationism because this imaginary psychogeographic drive plays a great role for Blake. ... From these sources, bridges can then be built to the reclaim-the-street movement in art today. And Belgium is also very important with Raoul Vaneigem whose pioneering work has been hugely influential to artists and architects ever since the 1950s.

When art is taken to the streets, is the demand of the Situationist International for art to be overcome? Have we arrived at a point beyond art?

An important reference is ~~Alexander Dorner with his book *The Way Beyond "Art,"*~~ which he wrote in the early twentieth century, and in which he shows that ~~we can only understand the forces at work in art if we call to mind the forces in other areas~~.

But in this way art was not abolished but extended. In the past fifty years since the founding of the SI, we have seen precisely the opposite of an abolition of art. Can it then be said that the idea of the abolition of art is something antiquated?

A more traditional approach can perhaps be found in the writer Peter Ackroyd, who has recently written a biography of London. With regard to neo-Situationist approaches, it seems to be interesting that once again a connection to the political dimension is being made.

People who don't come from artistic areas, but for instance, from politics or cultural politics, are interested in that. Could we, therefore, speak of a backward development, from the social context back to art?

Bertrand Lavier once told me that when you appropriate something and pull it into art, it is important that the transposition is at least as intelligent as the object itself that has been appropriated. That is unfortunately often not the case and there, perhaps, lies also a deficiency in this tendency to pull things into art. This position is very interesting especially when looked at in the context of David Deutsch's book, *The Fabric of Reality* [1997], in which parallel realities are investigated. I no longer believe that it is a matter of either/or, or that the one is dissolved in the other. Paul Chan is a political activist, but he is also an artist. And those are two completely different activities. With his idea of the *Fabric of Reality*, the scientist Deutsch succeeds in bringing together quantum physics, epistemology, the theory of computation, and evolutionary theory. He shows that these four branches come together and produce reality. Then you have what he calls the "multiverse." He speaks of parallel universes, of parallel histories, really, of parallel minds. Deutsch shows that in the end, information can always be tied back to atoms. It is not virtual; it is physical. And I think that this component is once again playing a role.

In quantum computations these four branches come together in information processing. Information is processed here when it depends upon the most diverse computations being superposed. It is not only a matter of parallel universes, but also of superposition. And in Paul Chan's practice, a superposition of the most diverse aspects can be ascertained. Multiverse is precisely the entirety of physical reality, and this contains the most diverse parallel universes. And in each universe, particles interact with one another. The reciprocal influence, however, is quite weak and only effective, if at all, through interference.

SI banked not so much on interferences, but on strict, international networking. Is that still appropriate today as a strategy?

These kinds of movements with common manifestos can no longer really be observed today. Rather, there are isolated individual positions. Of course, you always have to ask yourself why this form of movement is missing today. This is so not only in art, but also in other areas, such as architecture.

Do you see something missing there?

As Ernst Bloch would say, "Something is missing." [�֎ *dontstop*]

Perhaps figures like Guy Debord, who could provide leadership, are necessary again today?

Rem Koolhaas, Stefano Boeri, Kayoko Ota, Joseph Grima, and I posed this question last year to all the protagonists of the Japanese Metabolist movement of the 1960s: Kikutake, Ekuan, Kurokawa, Maki, and so on. It became apparent that the Metabolist movement was a very pragmatic alliance. It was more a matter of creating visibility through this grouping. And in this sense the question of alliances is topical. Even if today there are not so many alliances operating with manifestoes, it still can be observed that there is once again a great focus by many artists on such new alliances and networks. They are then, perhaps, not only alliances among artists, but also between artists and other disciplines. Today it can be seen very clearly indeed that these forms of alliances no longer take place only in one branch. And with this we come back to Deutsch. The idea of parallel universes could be applied again here.

The alliances that Guy Debord repeatedly set up and asserted were extremely rigid. Is something like that conceivable at all today?

Molly Nesbit, Rirkrit Tiravanija, and I also posed this question for ourselves with "Utopia Station." "~~Something~~

is missing" is of course the definition of utopia, given
to us by Ernst Bloch. With "Utopia Station," we thought
about what a movement could be at a time when there are
no longer really any movements. In fact, through "Utopia
Station" a group did come about, a group of artists and
architects who meet occasionally in various cities. But the
question remains: What connects this group? Of all the
exhibitions I have been involved with, it was here that the
concern with this question was strongest. And, thus, also
reflecting on a common social contract and so on. In any
case, that's an issue that "Utopia Station" took up.

*How important is the concept of utopia for the Situationists? Or
put another way: Thomas Hirschhorn sees what is problematic
with SI precisely in this point because, he claims, ultimately, this
utopian trait misled the French into permanent lethargy.*

There is a very informative correspondence between
Yona Friedman and Constant on this subject. It deals very
forcefully with the question of a master plan, which Yona
Friedman completely rejects. For Constant it is a matter of
what is called concrete utopia. Raoul Vaneigem invented
Oarystis, a self-organized labyrinthine city.

*In the 2005 exhibition, "Dionysiac" at the Pompidou Center,
Jason Rhoades and Paul McCarthy presented Guy Debord's
Mémoires, cut up and laid out in glass cabinets. What does
this reference mean?*

My conversations with Jason Rhoades in the 1990s always
revolved around the impossibility of capturing a city.
Jason's installations have a great complexity, but they
can never be as complex as a city. It is simply impossible
to portray a city. It has also always fascinated me that
even with the most diverse forms of mapping, it is not
possible to completely capture a city. We can only ever
quasi-capture the impossibility of the possibility.
 This was also our concern in the interview marathon.
In London that was particularly acute because the idea of

London was precisely the starting point for all these Situationist thoughts. If you reconstruct the topography of a city and also discuss the superpositions of local and literary references, then you repeatedly come across connections with Situationism, for instance, with Iain Sinclair and his project *London Orbit* [2002], in which he takes this incredible walk along the N25. There are suburban references that can almost be found which also remind me of Lucius Burckhardt.

~~The great Swiss Situationist~~, the landscape visionary, Lucius Burckhardt. He should not under any circumstances be forgotten. As the founder of the science of taking a walk, he succeeded in doing something that none of the Situationists before him had achieved. If you think about his magnificent walks—how he laid zebra stripes made of real zebra skin in the city, or how he blocked traffic with windscreens—his actions are obviously closely related to Debord. Debord called psychogeography the study of the specific effects of geographic surroundings, regardless of whether they are organized consciously or unconsciously. It's a question concerning how geographic surroundings effect the emotions and behavior of individuals. This combination of psychology and geography, as represented by psychogeography, seems to be the crucial point.

Lucius Burckhardt's walks took up this idea in an exemplary way. Of course, this has a connection with De Quincey and Baudelaire. Burckhardt is not just a utopian, but a concrete utopian. Here I am thinking of his quite concrete disturbance actions in Kassel. Or how he led visitors to the Villa Medici in Rome, from the exhibition to quite remarkable urban wanderings into the suburbs.

But I would like to take up a further point regarding the frequent branding of Situationism. There are now newspaper columns and products that use the phrasing "Situationist Drifts." And in this context, the resistance and political radicalism of an urban wanderer such as Gustav Metzger becomes important. Metzger came to London as a refugee in the 1950s and became one of David Bomberg's students. <u>One of the most radical statements</u>

came from Metzger at the interview marathon. At some
point he said he would now like to bring a manifesto into
play which demands that the art world stops making so
many journeys, in particular that it stops flying.

To come back to Lucius Burckhardt's walks once
again, the filmmaker Patrick Keiller—who also took
part in the interview marathon—has shown, there is a
danger in Situationism having become a kind of brand.

*Can the Situationist International be exhibited at all? And what
role does the museum play in doing so?*

This leads us back once again to the idea of mapping, where
it is not a matter of representation, but of a performative
space. In this connection it would be much more interesting
to transform this matter into a performative space instead
of only looking at plans or simply an exhibition. If concepts
such as drift, diversion, psychogeography, and dissipated
strolling are to be approached in the sense of the SI, it
is quite important that an oscillation be set in motion,
and that we go from the museum into the city, that, for
instance, walks take place. It would be wonderful if some
of the walks described by Guy Debord, Raoul Vaneigem,
or Yona Friedman could happen. It is very important that
the museum works as a kind of relay, and that from there
things go further.

There are so many neo-Situationist organizations.
For instance, the writer Tom McCarthy, who was also in
London at the interview marathon and is part of several
neo-Situationist organizations, should be mentioned.
He has just written a new book on Tintin, in which he
looks at the secret of literature and the invisible side
of Hergé—thus, what we said before about the invisible
city can be applied also to the invisible Hergé. Also
Stuart Holmes, and with this there is in turn a reference
to Gustav Metzger, who at some point announced the
art strike in London. Stuart Holmes also proclaimed a
strike. It can also be interesting to show these contem-
porary forms of Situationist practices.

*How has the role of the museum in urban space changed?
Compared to the 1989 exhibition at the Pompidou Center,
today there is certainly a better point of departure for
exhibiting the SI.*

Why is it better?

*Because the function of the museum in the public perception
and also in its own self-definition has changed. Has a process
taken place that has led to the SI being better able to exhibit
today in the institution of the museum than was the case ten
or fifteen years ago?*

That's a very general question. To be sure, if we take
strolling in the sense of Lucius Burckhardt as an example,
just the opposite is the case. In the same way that on
ski slopes the paths are signposted and always indicate
whether you have to go left or right. Today the institution
of the museum is running the danger that the homoge-
nizing forces of globalization will creep in here, too,
thus, leveling certain differences.

At this point, Édouard Glissant could be brought
into play as a further toolbox. [✿ *dontstop*]. Using his
ideas, we can think about how today the most diverse
models of museums can exist alongside each other. The
concepts already mentioned, such as dissipated strolling,
drifting, diversion, can perhaps play a role not only in
the city; we could also start thinking about how such
concepts come into play within the experience of the
museum in the sense that, for instance, there are faster
and slower routes. Complexity has become an increasingly
difficult issue in the museum. There we have all these
audio-guide devices. What is becoming predominant
is the idea of a homogenized ski slope on which the
exhibition is queried in a very linear way.

The Dada exhibition at the Pompidou Center in
Paris, by contrast, was a highly instructive example of
how this trend can be countered. Here the topography
of the exhibition was really a reconstruction of an

earlier show by Daniel Buren, on which the Dada exhibition was superposed. So at first there was the history of the Buren exhibition, and then on top of that, the Dada exhibition. There was no center to the exhibition; each visitor could define his or her own route through it. There were no instructions telling the visitor to turn left or right. That was part of the display that Daniel Buren had developed. And this was then filled with the contents of the Dada exhibition. The catalogue, too, is a magnificent example of a highly nonlinear source book. Such an exhibition provides optimism. Such projects today, however, are to be found more in European museums than in American museums, where there is an incredible compulsion to explain things, and where ambiguity is not permitted.

The big question posed is which path the museum will take in other geographies. <u>In China more than one thousand new museums will be built by 2100</u>, and there the question naturally arises to which extent new models can be developed. I believe that the approach of ambivalence and multiple meanings is very important for the future.

At the same time, however, the museum, under economic pressure, functions as an agent of the spectacle, as Debord would say. Will things remain that way, independently of how the problem is solved scenographically?

The museum is a site of the production of knowledge, of recollection in the sense of Eric Hobsbawm, ~~a place of protest against forgetting~~. Here the issue is recollection as a dynamic toolbox, a contact zone between past, present, and future. In this sense the museum is, of course, a very complex matter.

Translated from the German by Michael Eldred

I Was Born in the Studio of Fischli/ Weiss

with Nav Haq
2006

07

＊＊

Recently appointed Co-director of Exhibitions and Programs, and Director of International Projects at the Serpentine Gallery, Hans Ulrich Obrist, perhaps the most prolific curator of his generation, has recently arrived in London. A significant activity in his practice has been, and continues to be, the interview. His book Interviews Volume 1 *was published in 2003, a prodigious 500-page publication that gives a sense of the scope of ambition of his ongoing project. On the eve of the first "24-Hour Interview Marathon"—an event he initiated with architect Rem Koolhaas—curator Nav Haq caught up with Obrist to discuss his ideas about interviews as a research methodology, how they have played an inherent role in his curatorial practice, and why he believes they can generate cross-disciplinary dialogue.*

＊＊

Nav Haq — *My understanding is that you have been conduct-ing interviews from a very young age, perhaps even since your teenage years, and maybe even before you became involved directly with visual art. Can you recall how you first became interested in giving interviews?*

Hans Ulrich Obrist — ~~My curatorial work has come directly out of conversations. When I was a kid, perhaps sixteen or seventeen, I went to see Fischli/Weiss, and they said I should go see Boetti~~. And so I watched artists such as these working directly, which was important as my first contact with art. I visited many artists regularly, but Fischli/Weiss were the ones I visited the most. I watched them work on their film *The Way Things Go*. <u>I was born in the studio of Fischli/Weiss</u>. I was born in 1968 but was then "re-born," if you like, in their studio. I researched visual art throughout the 1980s, but then in 1991 I thought it was time to begin working more directly with visual art, and to present work in a domestic setting. After more conversations with Christian Boltanski and a first encounter with Gerhard Richter, I did my "Kitchen" show. I thought it would be interesting to do something unspec-tacular, something just in my kitchen. I invited six or seven artists to participate, and the show was seen by around thirty people. Jean de Loisy from the Cartier Foundation came to see it, and found it somehow special. After which they gave me a grant to go to Paris to live and work as a curator. Out of this I had a very intense dialogue with France. I conducted many studio visits with artists as well as lots of interviews. Around 1992 I was in touch with the museum in progress in Vienna, a very interesting initiative that I have collaborated with ever since the 1990s. The initiative often conducted interviews, and I would conduct interviews in television studios with artists—such as Vito Acconci, Félix González-Torres, or Luc Tuymans.

However, I found it more interesting to conduct interviews in more informal settings, like over coffee or in a taxi, and I thought it would be interesting to find

a way to record the interviews without dragging people into a recording studio. From that moment onwards I did audio recordings; and then in the mid-1990s the digital camera came onto the market, which I then started to use [and then stopped using as of 2007. See interview with Niermann.]. It has become a research method and the basis for my curatorial practice over the last eleven or twelve years. I have an archive of 1,600 filmed conversations. Most of which I have only used as text transcriptions, and have not yet presented as video. I haven't completely figured out yet what to use. Most get transcribed. The whole project is a ~~complex dynamic system with feedback loops~~—a learning system.

You have conducted a vast number of interviews, as your recent publication Interviews Volume 1 *succinctly demonstrates, with many practitioners—artists, architects, theorists, even scientists. You clearly see this as significant due to the discursive relationship they allow to develop between yourself and practitioners. To what extent do you consider this a part of your role as a curator?*

Around the same time that I was going to the studio of Fischli/Weiss, I found a ~~book in a thrift store by Alexander Dorner,~~ who ran the Hanover Museum in the 1920s, and later went to the United States. The book became my guide. It's not only about the museum but looks at object and process, and discusses the museum as being an environment of uncertainty. It was very visionary. Dorner had one thing in this book that he emphasized, which was that ~~in order to understand the forces effective in the art world, it is important to look at other fields of knowledge.~~ I am based in the art world, and from there I make these excursions into other fields. It was François Jullien who once said that as a European philosopher he didn't go to China to be exotic, but he works in China in order to understand European philosophy. For me it has not been about leaving the art world, nor to consume differences, but I try to go into architecture and venture into other fields. My projects have started to work in relation to

these other fields, and with architecture it has become particularly intense. Through this process, I've interviewed many architects in order to understand that field better. ~~I go with the idea that exhibitions are knowledge production and should be closely linked to memory.~~ Discussions with artists and architects of an older generation allow a dialogue with practitioners of the current generation through my projects. <u>I think we should have a movement against forgetting</u>, and I hope to be able to contribute towards that movement.

This touches on my next question: Do you think the interview is a space that encourages interdisciplinary discussion between art and subjects such as architecture and the social sciences? Besides convergence, is it also for you a case of leaving something in order to reflect back on that thing you have left?

This is very interesting. Initially it was always "one person going to see another person"—this is the normal interview setting. As one says in English—*two's company, but three is a crowd.* At a certain moment about six or seven years ago, I started to go see people with other people. For example, I started to go with Rem Koolhaas ~~to see people that were very important to him when he was a young architect—such as Philip Johnson or Venturi & Scott Brown~~. With Dominique Gonzalez-Foerster and Philippe Parreno, I went to see a lot of people who had been influential to them, such as Edgardo Cozarinsky, an Argentine novelist who is very important to Dominique. This method allows for a lot of different formats and different ways of approaching particular elements of a person's practice. There are all kinds of different formats that have evolved. It's almost like context has allowed for all different kinds of interview subcategories. I tried to write down the other day the different kinds of interview categories that exist, and there are eight or nine different categories of interviews. In the beginning, I did art interviews, science interviews, architecture interviews, but it just "happened" that I began to do interviews with

three people in this way. This is a form that can lead to convergence that comes out of mutual curiosity. At certain times, in 1993, 1996, 1998, I thought about leaving the art world as I thought it was too narrow, but the art world allows these different contexts to happen; it's the most interesting field. It has to do with ~~going beyond the fear of pooling knowledge~~. I do think the different fields are quite segregated. If an architect speaks it's architects who go to listen. If an artist speaks then it is the art world that goes to listen. I have always believed in aiming for moments of change, and my interview project has to do with desire, as well as because cross-fertilization between fields is missing.

How do you decide who to interview? Are the discussions always intended for publication?

I just always do them anyhow. <u>Maybe only 10 percent have been published</u>, with hundreds unpublished. I believe that one part of a curator's activity is not necessarily public. I think it is interesting to have unrealized projects.

When an interview is published it presents a certain trans-parency around your own practice as a curator. What do you believe that this transparency has to offer an audience?

Hopefully it can be a toolbox which encourages ~~the pro-duction of reality. When I started to read about art it started with David Sylvester. I read his interviews with Francis Bacon which were very long conversations~~. And also I started to read a book by Pierre Cabanne on Marcel Duchamp. It is three very long texts where he interviewed Duchamp in three very long sessions. For me these two interviews are key because they are a long-term interview series. If you sit down again and again with someone things start to happen which may be interesting for some-one to read. So far I have maybe not yet conducted a very long interview that is as good as these interviews with Bacon and Duchamp, but I try. I try to give an unprece-

dented insight into works over sustained periods of time; it's an accelerated activity. Unlike exhibitions where you have deadlines, conversations are where I can forget about time, or even liberate time.

There has been much discussion lately around curatorial practice and how the role of the curator has, to a great extent, taken over that which is traditionally held by critics. This is partly due to the level in which it is felt that curators have taken over the mantle of discussing artistic production. Do you believe that conducting interviews also visibly allows for your practice to extend into the spaces normally occupied by critics?

For me it is interesting to read artist's writings, ~~and I have edited Gerhard Richter's writings, for example~~. I don't think curators writing criticism or publishing interviews replaces traditional criticism but I think both curating and criticism are today in a rather fragile position. The market is unbelievably strong and has a bigger effect on the ground than curators and critics. Young emerging curators do not get enough support. I do feel that criticism and curating should be strengthened. How curators can be involved in the diversity of the art world is really important. There are curators, artists, critics, gallerists, and collectors, all of whom are forces. The art world, in the best case, is a polyphony of these different forces. As the visionary poet and philosopher ~~Édouard Glissant~~ says, the homogenizing forces of globalization also have an impact on the art world. ~~Glissant talks of *mondialité*, which is the chance for increased global dialogue, but at the risk of a loss of diversity and complexity~~.

Presently, the main criticism of art criticism is that it is too detached from the production of art and exhibitions, whereas curators are much more likely to present the discursive side of their relationships with artists. Do you believe the presence of curators such as yourself, who are up to speed with artistic production, particularly through conducting interviews, is a way for art criticism to advance?

Hopefully, the whole knowledge production side of artwork is getting stronger. Curating is very paradoxical because you could say, on the one hand, there is a lot of discussion around curating. There are symposiums, platforms for exchange, and also a lot of texts published on the subject. But it could be said that there's <u>a whole literature missing on the topic of exhibitions. I think it is astonishing that we have curatorial schools, but we have no literature on the history of exhibition curating</u>. What is missing are key texts. Dorner is still not in reprint, Pontus Hultén, Seth Siegelaub, and Willem Sandberg are not in print. Obviously, it is a new field, but there is a whole history of exhibitions missing. People always say to me, "Are you the grandson of Harald Szeemann?" He's one of my mentors, and, obviously, when I was a kid he was an incredibly important figure of reference in Switzerland. But the story of curating is much longer than that. I am interested in the pioneers from the early twentieth century, such as Félix Fénéon, Dorner, and Harry Graf Kessler.

Of course, there is always a discrepancy between an actual interview conversation and what eventually appears in printed form. This is most often due to the editing process in-between. Do you edit your own interview texts?

It's always a very multi-linguistic thing. When I grew up in Switzerland, there was no big city, but one thing I could do there was learn a lot of languages. There are a lot of Italian interviews, Spanish interviews, and Russian; a lot are in French, many are in English, German, and Chinese. Editors transcribe them, and do a pre-edit, and then I do an edit. It can be published immediately or even ten years later, or go into the archive, where there are even interviews in languages I cannot speak. Especially funny was the interview with Oscar Niemeyer, which we did with Fernando Romero and Stefano Boeri in Portuguese, and also interviews in Chinese. Niemeyer refused to answer questions in French, and spoke in Portuguese. When the interview was transcribed it really wasn't very coherent. It was like a *cadavre exquis*.

I find interviews interesting because they take on a form that both is and isn't temporal. The actual interview discussion itself possesses temporality, yet when it exists in printed form, it can take a shape that continues to have significance for different reasons at other times. Everybody has a different "critical metabolism." Have you had the experience of revisiting one of your own previous interviews and developing a different understanding of an artist's practice?

This happens frequently. I met Gustav Metzger yesterday for a long interview. I've had discussions with him before, in 1987, 1996, then we were out of contact, and ten years later we connected again with some questions, but a lot had changed. You revisit questions you raised ten years ago and your perceptions change. It happens a lot. Interviews happen in different situations. For example, I interviewed Trisha Donnelly during long walks we took together in Paris. And Anri Sala and I travel a lot together. [~~if one followed Metzger's advice, the art world should stop flying~~.] Whenever we have a minute we record things, and make what you might describe as "interviews on the move." It is a very physical activity and a collective project. It's interesting that you talk of "metabolism" because metabolism is quoted by a lot of architects now, referring to biology, ideas of urban development, and industrial design. It's about movement in relation to the city. Last year we developed an interview series in Tokyo with all the members of the Metabolist movement of the 1960s. The idea for the interview marathon here at the Serpentine started in the city of Stuttgart, where we thought we could set up a stage that would last for up to twenty-four hours. We had twenty-four completely amazing people, and drafted a kind of fragmentary project. This was the point of departure for the interview marathon in London (where we interview seventy practitioners about their work, the London of the future, and many other issues), in an attempt to engage with a complex city and develop a fragmented portrait of the city and its mutation.

The Importance of Being in the Kitchen

with Markus Miessen
Paris, Gare du Nord, May 2005

Markus Miessen — *Hans Ulrich, you have conducted hundreds of interviews so far. Why interviews?*

Hans Ulrich Obrist — Essentially, my work as a curator always has to do with the question of "what exhibition is necessary?" I have never believed in the idea of setting up spaces instead of getting people to do things that they do not want to do themselves. The really relevant exhibitions are those that have a historical necessity at that time: to be within one's own time, to be in the middle of things, but in the center of nothing. ~~From the very beginning, my whole work has been based on conversations, first with artists and then, in the second half of the 1990s, also with architects, scientists, and other practitioners. And this conversation has always been at the origin of all my shows. So one could refer to it as an "infinite conversation."~~

When did you start to record these dialogues?

It was the moment that Alighiero Boetti died, who was a close friend and also a mentor. I started to regret very much that all the conversations we had were suddenly gone. And I started thinking it would be nice to have a trace of what is the core of my activities. And that's when I started to make systematic recordings.

So it was a way of deflecting oblivion?

It became a kind of complex dynamic system: a cybernetic ~~feedback loop~~ without any ~~master plan~~.

Like an archive?

Exactly, but it was not planned; the archive happened. There was no key idea behind it in the sense that I suddenly had to do an archive, but it just happened in a weird way. Little by little, there was a demand for interviews, so people would publish them or they would also approach me and ask if I would interview certain architects or

artists for magazines or books. Another way for me to do interviews was through commissions, where I was being sent to places to interview specific people.

Are there precedents for this process?

I have <u>900 hours of video recordings</u> and in a weird way, in terms of learning about architecture, the interviews are like my school. I am not an architect; I have had no training in architecture, but rather studied economy and social sciences. <u>It is a bit like the Monica Pidgeon "kitchen lectures." Monica invited all the leading architects—from the young Jean Nouvel and Zaha Hadid in the late 1970s and early '80s to Robert Venturi and Cedric Price—to her kitchen in London. She would record their voices and make copies of their slides. So you can actually buy the audiocassette and the slides, and then—in your own kitchen— experience a lecture by an architect</u>.

Was the first version of "Cities on the Move" in Vienna a turning point for you?

Yes. By the second half of the 1990s, I started to invite architects and scientists to my exhibitions, because I felt that the whole idea of me as an art curator was far too limited. And I felt it was almost like a necessity to bridge the gap in a certain way to actually go beyond that fear.

You once raised the question "if art is supposed to be the language of individuality—of difference, even of freedom—why is it always displayed in a homogenous box, the world over?" Can you elaborate on that?

Hou Hanru and I basically invited architects and urbanists to "Cities on the Move." And in the beginning, they sent in maquettes and the kind of stuff they would usually send to an exhibition. But COTM was conceived as a "performative" space, not a representation of cities. Little by little, when the show toured, the architects started to work

more experimentally. So Toyo Ito started to work on an installation with movable strings—an opaque space, a kind of floating city. Rem Koolhaas became more and more involved and he did the exhibition design for the Hayward Gallery in London, with Ole Scheeren. He did an accelerated *Merzbau* [a construction of found items], which was inspired by the junk aesthetic of Kurt Schwitters. It all started to come alive. That was what the COTM experience was really about.

The re-questioning of the idea of the white cube gallery space seems to be very much in vogue. How do you account for that?

I have never been against the white cube, but I have always been saying that ~~the white cube is only one possibility surrounded by many other possibilities that are worth exploring~~ [❖ *dontstop*: Broodthaers's "one truth surrounded by many truths"]. It is very much about complexity. I think this whole idea that an exhibition can navigate through different varieties of space is an important one. For me, there have been different possibilities and obviously the idea is to draw such new spaces and to kind of invent them, but of course also to use existing spaces. I am very interested in house museums—~~the Luis Barragán House, the Sir John Soane house—and now I am working on a show for the Casa Federico García Lorca in Granada, which is another one of these museums~~.

What about the experience of time in an exhibition space? This seems to be a constant concern through your own projects.

If you look at how exhibitions function, they usually last for six to nine weeks; they have an opening and, after the opening, nothing changes anymore. It is, after all, a very homogenized time-set. If you look at the moments within exhibitions that really had an impact, they were often events that only lasted a few seconds. In the Philippe Parreno show at the Musée d'Art

moderne de la Ville de Paris, there was really this idea of using the exhibition as a time code. The show was programmed by Jaron Lanier, the American inventor of virtual reality. So, for example, when you entered, a film was being projected onto a remake of a Rauschenberg monochrome white painting. Once the film was over, some curtains automatically went up, the lights flooded the space, and the Rauschenberg painting once again became a white painting. A few minutes later, the curtain came back down and the painting again became a screen for projection. In another space, you had a film projected, but when it was not projected, you could see a photograph. Basically, the exhibition was all about the superimposition of different time codes as a time protocol.

You are often described as a nomad. How does one live in three countries simultaneously?

It changes all the time. I have often lived in two cities, so the idea has always been that I do not really belong to a geography. It is not so much about belonging to a single geography, but being in between geographies in some way. At some point in the mid-1990s, I had a flat in London. I have also been in Berlin a lot, when we did the Biennale, then in Asia for "Cities on the Move," and now it is pretty much between the Musée d'Art moderne in Paris and my work with *Domus* in Milan. Before, until maybe 1997 or 1998, I would really make very long journeys. I would travel for two or three weeks to certain regions or cities, almost like a *flâneur*. ~~And now, I make very short trips and I always come back, which is actually very interesting, because everything has to be compressed into twenty-four or forty-eight hours. So a day has to become a week and a week has to become a month~~. I want to find out about practitioners who emerged after 2000, to find out what they are doing. I see my role as mapping this out. I think it's really important to do that right now.

A
Protest
Against
Forgetting

with Gavin Wade
Sir John Soane's Museum, London, December 10, 1999
and Serpentine Gallery, London, May 16, 2006

⁂

I first met with the fast-talking, globe-trotting Swiss curator and serial interviewer Hans Ulrich Obrist as part of a series of interviews I was making with curators in preparation for Curating in the 21st Century, *a symposium and book which I organized at The New Art Gallery Walsall in June 2000. Obrist was a resident at Sir John Soane's Museum to develop an exhibition within the space. His time living in the museum allowed him to sensitively integrate artworks into its complex layering of artifacts and architecture intermingled in a labyrinth-like approximation of the workings of the mind. One of the participating artists, Douglas Gordon gave the exhibition its title, "Retrace Your Steps: Remember Tomorrow"[1] and it included film, sculpture, sound works, and badges by Cedric Price for the guards to wear as conversation pieces. We both felt there was more to say at the end of our scheduled time and agreed to continue the interview at a later date. The issue of* Dialogue *on the artist interview prompted another meeting with Hans Ulrich, now in his new position as Co-director of Exhibitions and Programmes, and Director of International Projects at the Serpentine Gallery in London. Obrist not only started his career by editing a book of interviews and writings by Gerhard Richter (1995)[2] but soon took on the interview as a compelling element of his curatorial practice, which verges on the role of the archiving artist—absorbing and sharing the knowledge of curators, artists, and other creative practitioners. Interviewing him seven years later afforded a chance to weigh up any shifts in Obrist's thinking and the art world's amnesia as Obrist's continuing battle against forgetting enters a new space with his current collaboration with Rem Koolhaas. Curator and architect together are conducting two 24-hour interview marathons: the first took place in Koolhaas's rising planet of a summer pavilion in July, testing London's identity and skyline, and the second will take place at the Frieze Art Fair in October. A mammoth* Volume 1 *of Obrist's interviews was published in 2003 and more volumes are promised, to be designed by M/M (Paris). One half of the design duo Mathias Augustyniak, joined us in a "trialogue," offering further insight into the workings of the HUO brain.*

⁂

Gavin Wade — *I came to the talk you and Hou Hanru gave at the "Cities on the Move" exhibition at the Hayward Gallery [1999], and there was something that was mentioned about the idea of the exhibition as an evaluation. I was wondering if that's a new thing that you were thinking of? That you, say, go to Southeast Asia and bring back a form of evaluation of something that is evolving with artists and culture?*

Hans Ulrich Obrist — I think I always see exhibitions much more as a ~~complex dynamic system~~, you know, and at the beginning the system is not really a hundred percent sure where it is leading. Something that I've always liked very much is the fact that exhibitions could be an ~~ongoing conversation~~. And an ~~ongoing conversation~~ is like every show I'm involved in. ~~It always starts with conversations, with artists or architects, and then develops into new conversations and triggers more conversations between different practitioners~~. In a sense, I don't think that it's necessarily an "evaluation," as you call it. It would be, for me, too much the idea that one would evaluate a certain given situation, which one then would try to transfer from one context to another. But I don't believe in this idea that one would actually try to represent a reality that exists elsewhere. I always think that an exhibition is a performative space, rather than a space of representation. An exhibition like "Cities on the Move" tries to push this to its boundaries or sometimes beyond its boundaries by really trying to be a performative space—the exhibition tries to reflect a performative city much more than a representation of a city. I think, to a certain extent, <u>what is interesting about certain works of art is that they develop a dynamic form of standstill</u>. That is also

1. "Retrace Your Steps: Remember Tomorrow," Sir John Soane's Museum, London, 1999–2000.
2. Gerhard Richter, *The Daily Practice of Painting—Writings and Interviews 1962-1993*, ed. Hans Ulrich Obrist (London: Thames and Hudson, 1995).
3. Hans Ulrich Obrist, *Interviews*, ed. Thomas Boutoux (Milan: Charta, 2003).

why Sir John Soane's Museum is of great interest—
as a model museum it's actually more like something
which would happen in your mind, but it's a very
~~dynamic thing of memory~~, like entering someone's
brain—a dynamic form of not only visiting historical
artifacts but also putting them in relation to each
other. Actually when a visitor goes to Sir John Soane's
Museum, no two visits are ever the same. There's a way
in which the visitor connects with objects differently
each time. Many museums are intimidated by the
viewer consuming something and so on. This is not the
case in the Soane because of the scale and because of
it being a private house—it has a domestic context.
When you enter the house, you have to sign the book;
it's like a kind of contract.

Yes, it makes you feel quite familiar with the space already.

Exactly, and then discussions are immediately triggered
with the guards, and visitors also start to talk to each
other. For example, take the picture room where Richard
Hamilton's painting is hidden behind other paintings
on hinged doors behind walls: one has to wait usually
until maybe seven, eight, nine people gather there
before the thing is opened. So often you have four or
five people waiting for other visitors to arrive, engaging
in a discussion. And I think again, this idea of exhibi-
tion display triggering a conversation is very important,
and I think in this sense we can really learn from the
Soane conditions.

I've noticed a push towards remembering in the interviews and
other texts, particularly the article or the Internet discussion
published in the Phaidon book Cream,[4] *where you didn't*
actually get involved in most of the conversation but you just
dropped in with this thing that most of them had forgotten
about. You said, "Don't forget about the people who have

4. *Cream: Contemporary Art in Culture* (London: Phaidon Press, 1998).

come before us." You seem very aware of history and the history of curators; has the conversational idea come out of that history, or is that quite a new innovation in curating?

~~I never want to overemphasize the importance of such curatorial questions, because I think to a certain extent they are not necessarily strategies, and they are not necessarily theories, but they really have actually come out of conversations. To a greater extent it actually has all started with conversations and what I've been doing has always been an infinite conversation and nothing else really. And out of this infinite conversation~~ there was a stage where I started to organize an exhibition in my kitchen because I was speaking to <u>Richard Wentworth</u>, Peter Fischli and David Weiss, Hans-Peter Feldmann, and Christian Boltanski. Some artists feel that there are all these exhibition spaces but they would rather do something in a more clandestine context. Boltanski said: "Why don't you do it in your kitchen?" And ~~it's always been a conversation really~~ ...

Were you just talking to them because you were interested in their art?

Yes, that's always the beginning of the dialogue. ~~I always feel it is necessary to mention Alexander Dorner and to mention all these things.~~ But the reason why I do it is actually not in order to historicize things, but to understand why these things are not known.

I actually want to see a chronological breakdown of important moments in twentieth-century curating, people, and exhibitions.

Well, that's obviously important and you have the exhibitions by artists also.

Definitely, yes. But there isn't a document that relates exhibitions in such a way ... the only thing I've found are things where you've

*mentioned stuff and then you can begin by looking back at
things. But I am more aware of, you know, post-1960 shows.
It's much more difficult to find out information prior to that.*

I started to get into the more historical issues related
to this curating question, again, ~~out of conversations~~.
I made a series of interviews for *Artforum* around 1995,
1996, and 1997. First of all with Walter Hopps, the great
American pioneer from the 1950s and '60s, then with
Harald Szeemann, and later Pontus Hultén. Yes, and
the idea of these interviews was really to start a history
of important curatorial positions in the 1960s and the
invention of exhibition models. Through these persons,
they are very familiar with the history of what came
before them ... I mean Szeemann is completely familiar
with Harry Graf Kessler, and Willem Sandberg is
completely familiar with Alexander Dorner. Little
by little, through interviewing the protagonists of the
1960s, I got more insight into the historical facts. But
what is interesting is that in the 1990s this whole cura-
torial discussion has been so accelerated that it would
seem that people don't even really remember, but they
obviously do remember, in some sense, because they
have been influenced *indirectly.* If you speak to Norman
Rosenthal in London, for example, he would very often
cite Harry Graf Kessler. So the generation before us
is very aware of the historical references: Félix Fénéon,
Harry Graf Kessler, etc. If you think that Dorner invited
El Lissitzky to make the Lissitzky room, the "Kabinett
der Abstrakten" in 1927, it would be quite a daring thing
to do at a museum now: to invite a contemporary artist
not to do a show, but to actually hang the collection
in a room where the artworks of other artists could be
moved around (or "curated") by the visitor. And these
are just ideas I'm very interested in, that I think we can
learn a lot from. I think it's extremely necessary right
now to rediscover these positions. And I think it is very
reductive, the white cube ideology, how it's developed
basically in the last thirty years in a very small part

of the Western world—not only in America and Europe. This white cube ideology has become such a strong ideology that it's actually almost prevented anything else from happening. I'm not against the white cube ~~but as Marcel Broodthaers said, "It is only one truth surrounded by many other truths worth being explored~~."

It has its usefulness.

There's the Whitney-type of museum, there's the Guggenheim-type, and then there's the Soane-type of museum: let's put them all in the same building. A museum shouldn't be reductive; there should be different forms of museum conditions, different forms of experiences, if possible, to enable the freedom to move.

Serpentine Gallery, London, May 16, 2006

I was wondering, just to start off with, how you think the land-scape, the notion of a curating landscape, might have changed since 1999, when there seemed to be a much greater lack of knowledge about the history of curating. And also how some of your own efforts have started to inform practices.

What is interesting is that there is, I think, ~~still missing literature~~ and <u>a certain amnesia of curatorial history</u>. The other day when I arrived in London ... it's the third time I have lived here because I lived here in the 1990s first when I did "Take Me (I'm Yours)" for the Serpentine in 1995, and then when I did research for the "life/live" exhibition at the Musée d'Art moderne de la Ville de Paris in 1996, and then I lived here again for a year, on and off, at the Soane House when I did "Retrace Your Steps: Remember Tomorrow" [1999–2000] ... and so coming back here I felt that I should go to see the historian Eric Hobsbawm, after he had written *The*

Short Twentieth Century.[5] I was very curious to see how one of the great historians of our time sees our somewhat strange decade at the beginning of the twenty-first century. <u>And he said something—which he had actually said once before to David Frost and to Simon Schama, the historian on *BBC Breakfast*</u>—he said that his work is a ~~protest against forgetting~~, and that sort of whole notion, ~~a protest against forgetting~~, I was thinking is a nice motto for our discussion really because that's what the interview project is to a certain extent.

The interview project started actually ~~with David Sylvester, because when I was a kid in Switzerland, this book by of interviews by him on Francis Bacon~~ was quite popular. I got a copy of this book when I was maybe, I don't know, sixteen or seventeen or even earlier. And I kept reading this book and I thought it's actually really most exciting that an art critic would talk to an artist again and again and again and create this unbelievably intense dialogue. And this was somehow the blueprint really for a lot of my interview projects afterwards, later—not so consciously but it sort of entered somehow, ~~because I've been doing these very, very long-term interviews with artists~~. I mean if it's Gerhard Richter or if it's Daniel Buren or Anri Sala or Rosemarie Trockel or Dominique Gonzalez-Foerster, I've interviewed them again and again and again.

But that project in a way isn't so much about combating forgetting as really mining in deep to make sure you get the real essence of what the artist or the individual is really trying to do, isn't it? That's why you would go back for more? Whereas the other idea of not forgetting ...

Yes.

5. Eric Hobsbawm, *Ages of Extreme: The Short Twentieth Century 1914–1991* (London: Abacus, 1995).

I was just wondering when was the switch, when was the first time you realized that you'd done so many interviews that you were beginning to be an archive of some kind?

It happened all so seamlessly because at a certain moment it became relevant to record the conversation. Also artists would talk about other artists and I would meet younger architects and they would all talk about Yona Friedman, so I would ring up Friedman and go to see him, or at a certain moment Lawrence Weiner would say you should go and see John Chamberlain, so I would go and see Chamberlain, and I would go back to that generation. Or Dominique Gonzalez-Foerster would tell me about the ninety-five-year-old ex-student of Le Corbusier, André Wogenscky, who lives with his partner Marta Pan, a sculptor in her eighties, in this strange environment, sort of a modern house of the 1950s in the suburbs of Paris. So to see someone with someone else—that added a lot to this archive. And it also has to do with the fact that the engine for the interview project is really curiosity. ~~I mean, I believe that also with Dorner, you know; if we want to understand the forces which are effective in the visual arts than we have to look at what happens in other disciplines.~~ So I started to visit scientists like Benoît Mandelbrot [Ed. Note: "Clouds are not spheres, mountains are not cones, coastlines are not circles, and bark is not smooth, nor does lightning travel in a straight line." From the introduction to *The Fractal Geometry of Nature*, 1982] or Ilya Prigogine [chaos theory, self-organization, etc.], and I started to visit all kinds of people who have had an influence on the art world from other fields, from mathematicians to people from the field of architecture. So at a certain moment, you know, ~~that all happened in~~ a sort of seamless way, and it ~~evolved like a complex~~ dynamic system with feedback.

But then the day I became conscious that it's important to have this memory element, this ~~protest against forgetting~~, was about six or seven years ago with Rosemarie Trockel in Cologne. I was with Rose-

marie in her studio, and Rosemarie said I know that you're doing this interview project, you should really focus on memory; you should really focus on hundred-year-old people, whose eyes have seen the whole century! You should interview them all, you know, all the great artists and architects. Rosemarie and I made a list that day of who these hundred-year-old people would be. Nathalie Sarraute, you know, who was still alive then, Paul Ricœur the philosopher, and Oscar Niemeyer the architect. I've done this quite systematically ever since. It's very incomplete but there are these sort of different branches of the interview project, and there's ~~not been a master plan~~, it happened little by little. So there are the interviews with the centenarians, the people who are eighty, ninety, one hundred; there is this rhetorical sort of aspect; and then there are the interviews where one would go with an artist to see his or her hero. I mean for example, ~~I started to go with Rem to see all the old architects who inspired him as a student~~, so we would go to see O.M. Ungers, ~~Venturi & Scott Brown~~, and ~~Philip Johnson~~. I would say that's the second part of how to go back to the past. Then the third part is, obviously, this whole idea of going into other fields, science and all of that, and having great figures of inspiration from those fields, which very often then leads to the previous generation.

At that point was there any sign of thinking of parallels to other societies or roles of individuals within societies? I'm thinking of the notion of maybe a non-Western idea of certain individuals within a community being the recipients and holders of knowledge to be passed on from generation to generation. Perhaps I'm imagining an African community where maybe one person is born into the role and taught the names of every family member who's connected or the family stories. And then if they tragically die, that history would be wiped out because they're meant to pass it on to their children. Your tracking down and interviewing has this feel about it, a sense of instinctive social archiving.

Yes, I mean, if I go to see Pierre Klossowski, who was friends with Walter Benjamin and Georges Bataille, or if I go to see Hans-Georg Gadamer, who was close with Martin Heidegger ... so through my interview project the whole twentieth century has been told to me, but instead of through books, it's been through people who knew those people. Your question also leads a little bit to the history of curating. At a certain moment I began thinking, OK, I'm doing these different interviews, but there is this ~~whole literature that is missing~~ on the grandfather or grandmother figures within my own field—which is curating—and it's always reduced to Harald Szeemann, who is very important but, you know, he's not the only one; there are other heroes. And Szeemann himself has said how important Hultén ~~was and Seth Siegelaub and also Jean Leering. I mean, Szeemann mainly pointed out not Leering but~~ Sandberg; he liked Sandberg a lot. And so at that moment I thought it could be an interesting subject to go and see all these pioneering figures ~~and grandfather and grandmother figures~~ of curating in a certain way. And that if they tell me their story, one could have the whole history of twentieth-century curating as told by ... So I would go to see Anne d'Harnoncourt, the daughter of Rene d'Harnoncourt, the director of the Philadelphia Museum, who was a pioneer of the MoMA and who died tragically quite young. In some way, as most of these stories are oral histories—and your example has to do with oral transmission—and most of curatorial history is oral history ... you know, there are almost no books on Sandberg, but there are his recorded radio conversations. The same is true for Leering and all of those people; it's very much a story which can only be told because it's not yet been written.

Is that actually partly due to the idea of the curator being behind the scenes and being invisible, that it was almost rude to be seen or heard? Maybe that's the thing, that at a certain point it didn't become so rude for the curator to be visible.

Yes, in my whole way of arguing, there has always been this rhetoric about the curator being invisible: ~~Duchamp once~~ told Walter Hopps that "~~the curator should not stand in the way~~," and I think that's very important.

That's a quote, is it?

And I still believe in that, so ~~I don't think the curator has to be visible at any rate~~, but obviously you have a point; it might be related to the fact that it wasn't decent to be seen, but that's not the only reason. For example, Jean Leering, the great curator of the Van Abbemuseum in Eindhoven who did this exhibition called "The Street: A Form of Living Together" [1972], which was such an influence on "Cities on the Move" [1999], you know, many people have quoted it as a key reference. I did a long interview with Leering who passed away this year. I could not publish this interview anywhere, even in Holland. It didn't come out during his lifetime, and now it will be translated for Paul O'Neill's forthcoming publication. And then I'm working on a book where all these curatorial heroes, ~~that is to say, our grandfather and grandmother figures~~, will be gathered, i.e., Walter Zanini, who, under a dictatorship put forward the São Paulo Biennale, and interviews with Franz Mayer, Pontus Hultén, Johannes Cladders, etc. It's not only Western history. This will be followed up by two long interviews with Suzanne Pagé and Kasper König, my teachers and mentors.

I think you've already mentioned some of your principles of curating, which I think then must tie into the interviewing because you mentioned how you have traveled around the world and how you have met all of these people. Previously you have spoken of how you don't believe that curators should be creative for their own sake, but that you're creative by being led or pushed by an artist or architect to go somewhere, that they're telling you to do this <u>thing</u> and that would be the <u>thing</u> that you were led to do.

That's one dimension of my methodology.

But then how does the actual act of interviewing compare?
I think, the interviewer cannot be invisible, which is a parallel
to the notion of the curator: to believe that the curator is
invisible or the interviewer is invisible is about denial or
producing an artificiality, which could be interesting if that
was the point.

But that might be a parallel between curating and archiving, right?

Yes.

And there are also differences so I think it's important when you talk about parallels to talk about differences.

Yes.

And I think both exist. And I mean definitely, there is a parallel, but I think that ... because I'm doing this book right now, which comes out next month, which is about all the prefaces.[6] I was in a café in Paris with Caroline Schneider and we wanted to do a book. I had just bought this book by Jean Oury, who did this incredible, free, open clinic called La Borde with Félix Guattari. So I told Caroline that he had just brought out this book of prefaces. And so, together with April Lamm, we worked over all the prefaces I had previously written for catalogues to create a sort of strange chronology. Rem Koolhaas, in turn, wrote the preface to my prefaces, and in it he analyzes the differences between the interviewer and the curator.
 Something I should maybe say beforehand in terms of how these interviews happened is that obviously chronology cannot be separated from my travels. I've

6. Hans Ulrich Obrist, ...*dontstopdontstopdontstopdontstop* (New York and Berlin: Sternberg Press, 2006).

been on the road nonstop from 1991–2000, and I still travel every weekend, on shorter journeys. Very often there is a reason: it's either for a lecture or to curate a show or I'm invited to do studio visits. At a certain point, there is also the question of what is the sense of all of these travels. As a side activity, I started then to think up a way for me to make sense of the whole journey, so that I use each place for research as well. So that's why I started to record the interviews, and obviously I had certain questions that I would always ask, like who is a pioneer, who are the artists from the past that inspire you, and one thing would lead to the next. It's very much about a post-planning condition.[7] It's a way of being an ongoing *flâneur*.

To come back to the thing about the interview, Koolhaas says that the profession of curating is about thumbs up or down, a system that picks, displays, and judges. He was always astonished by the certainties he found in the curatorial fields of what is good and what is bad. On the one hand, he says that as a curator, one is always committed to this process, but at the same time that the commitment to the interview is maybe a counteraction to curating's stranglehold. That the interviewer is somehow, in this regard, also the opposite of the curator: that the interviewer is curious where the curator's mind is already made up. Where the interviewer is promiscuous, unedited, and expurgated, the curator is selective and exclusive. [❋ *dontstop*]

But, in some ways, he's talking about power relations ... the curator may have to listen to an artist in a different way than an interviewer may have to listen to an interviewee. And maybe you don't have to do as much post-planning as a curator. I mean, I think post-planning in curating is really exciting ...

7. Hans Ulrich Obrist uses the term "post-planning" in the way that Hou Hanru uses it: "You start to build a bridge and find out on the way where the bridge goes." (E-mail correspondence from Hans Ulrich Obrist, September 2006.)

But that's one aspect that I've been interested in and what brought us together in the Guangzhou Triennial, where you curated the post-planning section. That is definitely the case. Koolhaas is probably right that a lot of my sort of post-planning ideas came from the inter-viewer and influenced the curator. So I would go and see ~~Yona Friedman and Cedric Price~~ who would tell me about the non-plan and post-planning and I would then incorporate that into the curatorial practice. So there will certainly be a dialectic between the two, and it's not, I mean, for me these interviews have very often to do with getting feedback afterwards into the exhibi-tions; so it's a back and forth really, it's a dialectic. Koolhaas also says that basically it's a humble process.

Humble?

Yes, that it's a humble process: the interview is about listening and not about imposing questions. Koolhaas also says it's about posing normal questions with such urgency that they lead to corners of unexpected revela-tion. It needs multidimensional attention. He says that it's about an effort to preserve the traces of intelligence from the last fifty years [✳ *dontstop*], to make sense of the seemingly disjointed: a hedge against systematic forgetting [... vs. a protest against]. And then he says, that obviously a lot of these elements of the interview are also built into the practice of curating.

Can you tell me about the interview marathons at the Serpentine? They seemed to me like an extension or a play on this ~~notion of the infinite conversations~~ that is mentioned at the start of your interview book.

Yes, so at a certain moment, director Marie Zimmermann and program director Christine Peters, both of the theater festival of Stuttgart, you know, the one in Germany called the "Theater of the World," came to see

me and they said, "We want visual art in the theater.
Could you curate something?" And so I thought about
what could happen on stage. Obviously, it would be an
interview, but it would have to be an interview marathon.
And then I was thinking about Italo Calvino and
I was thinking of how one can map the invisible city.
And so I was thinking that maybe it would be good,
before we do this in a big city like London, to test it in
Stuttgart, because I was a bit insecure. And we did a
24-hour marathon. We came up with quite a list of all
these practitioners in London, and actually ended up
with an incredible list even for a place like Stuttgart,
ranging from Werner Spies, an art historian, to Günter
Behnisch an architect, to Kurt Weidemann, the graphic-
design pioneer. So in some way what it became is really
also this idea of a portrait [of a city]. I've often thought
about this idea with Stefano Boeri about this impossibility;
when we did "Mutations"[8] we were concerned with this
idea that it's impossible to do a synthetic image of a city
because the city is so complex. The late Oskar Kokoschka
pointed out, when he was making a city portrait, that
the city has already changed by the time the painting
is done, so how can you do a synthetic image of the city?
The idea of an interview marathon has also to do with
a partial portrait—people are cities, cities are people,
and then through all these practitioners you get an idea
of the score of the city. Some come at night, some come
during the day, some stay for the whole marathon, and
then we found out after the marathon in Stuttgart that
lots of dinners had been triggered—which of course
I wasn't part of because I was sitting there—but a lot of
people went off at two in the morning and said, "Let's
go and eat, what is still open?" So there were all these
people meeting each other after the marathon at the
only restaurant that was open. And so it's almost like

8. Rem Koolhaas, Stefano Boeri, Sanford Kwinter, Nadia Tazi and
Hans Ulrich Obrist, *Mutations* (Barcelona: Actar; Bordeaux: arc en rêve
centre d'architecture, 2000).

you build a community, because the visitors come to know each other and are not just consuming a lecture and going home. Also, in a city like London, like in any big city, when you push the button, you know, you push the button, and when you invite somebody from the architecture world, then it's the architecture crowd that comes. Similarly, when you invite somebody from the art world, the art people come. We had an amazing talk at the Serpentine the other day by Tony Benn, and there was a huge crowd, but hardly anybody from the art world. So what is interesting, you see, is that each speaker brings his audience and it's his field, and there's no crossover. But through these marathons, it's obviously possible to crossover fields a bit because you come at three in the morning to listen to people and afterwards you have a young graphic designer and maybe you stay, and then that leads you to ...

So you're doing two marathons with Rem Koolhaas? What's the difference between the two?

We're doing one at the end of July, and one during the Frieze Art Fair. The interviews will be very much about the impact of globalization on the art world; and the one in July will be about London and more local, and so it's very much about what Cory Doctorow says in his great novel: it's about people coming to town and people leaving town.

When I was looking through your interview book I could only see a number of set questions: the main one being your end question of wanting to know what people haven't yet been able to do, their unrealized projects. And the other question is the one that you've mentioned about getting them to tell you who else you should seek out in the world to interview, who are their heroes. Will that still work for the marathon interview?

Rem Koolhaas and I are going to ask the questions together, so it's not like I would do the interviews on my

own. But the thing which is for sure is that I'm going to stubbornly ask the only question which pops up in all my interviews, and that's the question about the unrealized projects. I find it so fascinating as an archive, this whole idea of what hasn't worked out. First of all, these are projects which are about failure: in China failure is a positive aspect [❋ *dontstop*], and I think in the Western world, we are scared of failure, so very often we forget the benefits of it. And then the other thing is that in the architecture world a lot of reality is produced by architects publishing unrealized projects, whilst in the art world these projects are never published [❋ *dontstop*]. That's why, when I started at the Serpentine, Julia Peyton-Jones and I decided to instigate the Agency of Unrealized Projects. We are not only going to publicize these projects but also try to make them actually happen.

[HUO's mobile rings.]

Hello, Mathias. Mathias is designing the books related to the interview, the series for Walther König Books.

Hi, Mathias. So you've been able to capture the essence of how an interview might be an artwork, or something like that, in the way that you've approached the design of the books?

Mathias Augustyniak — *I think it was more related to the way Hans is always starting several conversations at the same time, and they are ~~ongoing conversations~~. Maybe it's <u>like an organ, you know, you start a note and the notes respond and you call them harmonies of conversations</u>. And in the layout we try to convey the same sort of harmony of conversation. With the prefaces in* dontstop ... *if you just read them from start to end ... I don't think it's really a good way to read them. It's more like when you look at a landscape: when you have another look, you might start to focus on the modern parts of this landscape.*

140

The first interview book works like that in a certain way, because I would open the book to the interview with Yona Friedman, and then that interview would end and depending on who's next, I might read that one, or then there might be certain curators I'd track down. But you stumble across things by doing that somehow.

Hans Ulrich, can I just ask you what is your unrealized interview, the one that you still haven't managed to make happen?

There is, you know, the unrealized project which will forever be unrealized—and it's referred to in the interview book, which is dedicated to On Kawara, but few people know that he's referred to also on the cover—it's a secret code. <u>The microphone on the cover is a photograph by Hans-Peter Feldmann, and it's switched on so you can see the word ON. That's our match to On Kawara, because, you know, On Kawara never gave an interview in his life and he never will—a necessary impossibility</u>.

Can Exhibitions Be Collected?

with Noah Horowitz
2006

✳✳

The next step for exhibition practice is the possibility of lightness, and a subtlety, density, and intelligence, through the invention of a flexibility that allows us to best adapt the structures we have and imagine new, supple ones for the future.[1]

✳✳

1. Hans Ulrich Obrist, "Shifts, Expansions and Uncertainties: The Example of Cedric Price," in *Curating with Light Luggage: Reflections, Discussions and Revisions*, ed. Liam Gillick and Maria Lind (Frankfurt am Main: Revolver – Archiv für aktuelle Kunst, 2005), 71.

Noah Horowitz — *I understand that you studied economics as an undergraduate. This fact seldom surfaces in discussions of your practice—discussions which focus almost exclusively on your hyperactive itinerary of interviews, conferences, and exhibitions. Could we begin by returning to your academic roots?*

Hans Ulrich Obrist — Certainly. I studied economics, political science, and sociology at St. Gallen University [Switzerland] in the late 1980s with Ota Sik, who was formerly the Economics Minister of Prague in 1968 and a vocal proponent of establishing a "third way," an alternative to capitalism and communism.[2] I attended his lectures when the Berlin Wall came down in 1989 and for a few weeks, he became a global media star— his ideas got reactivated. Everybody was suddenly asking: might there be a "third way"? Exploring this potentiality, bridging gaps, has thus been an elemental impulse of mine. Huang Yong Ping reiterated the importance of this to me some years later: normally, he explained, <u>we think a person should have only one standpoint, but when you become a bridge, you must have two—one which is balanced and another which is less stable, floating</u>. [❖ *dontstop*] The bridge is always dangerous, but fundamentally positive; it creates the possibility of opening up something else. Another important professor was Hans Christoph Binswanger who lectured on negotiations between ecology and the economy. He was an advocate of sustainable systems which would help avoid [James]

2. In April 1968, Sik was appointed Vice-Premier and Economics Minister in Alexander Dubček's reformist Czechoslovakian government which attempted to achieve "socialism with a human face." Prague '68, or "The Prague Spring," refers to the period of political liberalization in Czechoslovakia commencing January 5, 1968 (with the appointment of Dubček to power) and ending on August 20 that year when the Soviet Union and its Warsaw Pact allies invaded the country.

3. Obrist is referring to Lovelock's "Gaia Hypothesis," first advanced in the 1960s and formally published in the late 1970s. For further reference, see James Lovelock, *Gaia: A New Look at Life on Earth,* 3rd ed. (Oxford: Oxford University Press, 2000); and Hans Christoph Binswanger, *Money and Magic: A Critique of the Modern Economy in the Light of Goethe's Faust,* trans. J.E. Harrison (Chicago: University of Chicago Press, 1994).

Lovelock's infamous apocalyptic scenarios in which environmental abuse becomes a boomerang of a self-destructive economy.[3]

How have their ideas affected your approach to art? It appears that early projects such as "Hotel Carlton Palace" [1993] in which you set up shop in a hotel room and exhibited art out of a suitcase, or "Cloaca Maxima" [1994] in which you turned a sewage refinery into a temporary museum, are influenced by a pursuit of Sik's "third way": circumventing traditional institutional venues. Were you attempting to propose a different economy for art reception?

While I've always admired the innovative guerrilla production methods pioneered by various art movements in the 1960s, many have become mainstream management paradigms.[4] I would say that a guiding principle of my practice has been to "complexify" this situation and to introduce other viable models, experiment with other circuits. Alighiero Boetti told me when I was about eighteen that I'd be a redundant curator for him if I just filled exhibition spaces with shows; "routine is the enemy," he'd insist. This is something I'll never forget. To return to your first question, a leading impetus for studying economics, and the social sciences generally, was to gain exteriority on my practice. ~~François Jullien~~ has greatly influenced me in this respect: ~~to understand European philosophy, he maintains, he had to go to China~~.[5] Hence, although I long knew that I wanted to work with artists, it was only upon establishing this perspective and speaking with artists that I streamlined my ambitions. ~~Conversations~~

4. On this process, see Luc Boltanski and Eve Chiapello, *The New Spirit of Capitalism*, trans. Gregory Elliot (London: Verso, [1999] 2005).

5. François Jullien is professor at the Université Paris VII Denis Diderot, member of the Institut Universitaire de France, and Director of both the Centre Marcel-Granet and the Institut de la Pensée Contemporaine. Two of his most recent books include *Detour and Access: Strategies of Meaning in China and Greece*, trans. Sophie Hawkes (New York: Zone Books, 2004); and *In Praise of Blandness: Proceeding from Chinese Thought and Aesthetics*, trans. Paula M. Varsano (New York: Zone Books, 2004).

with Boetti were key [...] Peter Fischli and David Weiss, who were based in my hometown, Zurich, also helped me formulate my ideas. The Way Beyond "Art," Alexander Dorner's manifesto of the installation and the museum as a perpetually evolving form, really accelerated my interest in curating and his book was for many years my template, my toolbox.[6]

You've extensively discussed Dorner elsewhere, but I wonder how his work influenced you?[7] Similarly, what was the impact of your early discussions with Boetti or Fischli/Weiss?

We might as well depart from Boetti. For instance, it was he who insisted that we play with distribution mechanisms and inaugurate a project on an airplane in the form of puzzle giveaways. I thought this was brilliant, and in collaboration with the museum in progress, we ended up getting Austrian Airlines to finance a project whereby Boetti would exhibit his art on-board their flights for one year ["Cieli ad alta quota," 1993].[8] This introduced an amazing and rather peculiar circulation in which tens of thousands of puzzles—Boetti artworks—were dispensed for free to curious passengers. Interestingly, because Boetti is now deceased, these have come to trade as rare artifacts and I've seen them pawned in shops for artist multiples and flea markets from London to Asia. Therefore, what is endlessly fascinating to me is that through an unusual dis-

6. Alexander Dorner, *The Way Beyond "Art": The Work of Herbert Bayer* (New York: Wittenborn, Schultz, Inc, 1947).

7. On Dorner, see Hans Ulrich Obrist, "Moving Interventions: Curating at Large," 2003; Hans Ulrich Obrist, "Evolutional Exhibitions."

8. Boetti made six versions of this work over the course of 1993, each accompanying the bimonthly in-flight magazine, *Sky Lines.* The work thus appeared in the magazine itself, and in puzzle form by request from one of the airplane stewards. The jigsaw puzzles were made the same size as the airplane's folding tables. The museum in progress was founded in 1990 by Josef Ortner and Kathrin Messner and organizes temporary exhibitions in various contexts (newspapers, magazines, billboards, TV, the Internet, etc.) and often in collaboration with participating artists, curators, and media organizations. For more information on the museum in progress, and on *Cieli ad alta quota,* see mip.at.

tribution mechanism—the entire fleet of an airline—these puzzles gained another life, something that a more narrowly defined "art object" produced for a gallery or museum could never quite attain. It's all about challenging conventions ~~and this is something I've learned from Boetti, as I have equally from Fischli/Weiss or Dorner~~. The art world tends to be predicated upon a fundamentally simple economic model in the sense that there is basically no economy other than the economy of objects. We must experiment with ways beyond objects.

With regard to the market's insatiable demand for these "limited" artworks, Seth Siegelaub is an exceptional reference point.[9] An entrepreneur with an advertising background, he eventually represented many seminal New York conceptual artists— Lawrence Weiner, Carl Andre, Robert Barry, Joseph Kosuth, and Douglas Huebler, among others—and in tandem with them, he rigorously tested how art can be exhibited, experienced, circulated, and so on. In so doing, he famously deserted his midtown gallery in 1966 and began showing art out of his apartment—an act that recalls your hotel exhibition. Yet, from an economic perspective, one notable difference between this generation, especially Siegelaub, and yourself is your centrality within the "art institution." Indeed, Siegelaub departed the art world in the early 1970s, whereas you're an eminent international curator and your "Point d'ironie" artist poster project is funded and distributed by a major fashion outfit [agnès b.]. How easy is it for you to challenge conventions and simultaneously appease these public and corporate interests?

9. On Siegelaub, see especially Alexander Alberro, *Conceptual Art and the Politics of Publicity* (Cambridge, MA: MIT Press, 2003); see also "A Conversation between Seth Siegelaub and Hans Ulrich Obrist," *TRANS>*, no. 6 (1999): 51–63.

10. "The Kitchen Show"("Küchenausstellung") took place from July to September 1991 in the kitchen of Obrist's apartment at Schwalbenstrasse 10, St. Gallen. The exhibition included works from the following artists: Christian Boltanski, Frédéric Bruly Bouabré, Hans-Peter Feldmann, Fischli/Weiss, Paul-Armand Gette, C.O. Paeffgen, Roman Signer, and Richard Wentworth. For further reference, see Hans Ulrich Obrist, ed., *World Soup Küchenausstellung 1991* (München and Stuttgart: Oktagon Verlag, 1993).

To begin with the beginning, "The Kitchen Show," 1991, was really the culmination of six or seven years of research.[10] It was deeply indebted to the advice of Fischli/Weiss and Christian Boltanksi; it was the first statement I felt necessary to expound. After this slow and deliberate process, 1991 marked a transition to more international shows: dialogue commenced with Kasper König—enabling "The Broken Mirror" [Vienna, 1993]—and I received a grant from the Cartier Foundation which led to the beginning of my relationship with Suzanne Pagé and the Musée d'Art moderne de la Ville de Paris.[11] The "Migrateurs" series I inaugurated in 1993 was an intuitive reflex to this—an attempt to locate the exhibition both inside and outside the museum [...] to have exhibitions where one least expects them.[12] "Migrateurs" thus grew out of principles similar to those that motivated me to found the Museum Robert Walser [est. 1992] in the Hotel Krone's restaurant, the place where Walser stopped during his legendary walks.

I think we should approach your larger question about my role within the art institution by way of how the economic forces of globalization have impacted the structure of the art world. On one hand, this has increased homogenization—especially of space and time. But it also leads to reactions which refuse global dialogues and lead to closures. Édouard Glissant has been an unparalleled influence in terms of how I've negotiated these factors, understanding how to trigger and reinforce global dialogue whilst enhancing differences. One possibility has been to work with small shows in big museums, to insert small

11. Curator Pierre Gaudibert (1928–2006) created an agenda for contemporary art, ARC, at the Musée d'Art moderne de la Ville de Paris in 1967. From its inception, ARC maintained an independent operating budget and personnel, functioning uniquely as a site of exhibition-making rather than conservation. Suzanne Pagé took charge of this mission in 1973, and in 1988, became Director of the museum at which point she integrated ARC into the Musée d'Art moderne's mission and infrastructure, establishing a contemporary art acquisition program and a permanent exhibition space.

12. Since its inception, "Migrateurs" has invited over twenty-five artists to intervene both within the Musée d'Art moderne de la Ville de Paris, and elsewhere in Paris.

spaces within larger ones (and vice versa). Another option is to re-inject different temporalities, to edit or play with the time codes of an exhibition. There's also an interesting rapport here with the art economy because by inserting myself into a multiplicity of contexts, I've never had the luxury of relying on uniform modes of financing or distribution. For example, although early projects informed institutional shows like "Cities on the Move" [1997–1999] or "Laboratorium" [1999], they are all diverse in terms of what they produce, to whom they are addressed, and how they are physically manifested. In contradistinction to the pre-packaged blockbuster model, the logistical complexity of these shows means that despite my supposed branding power, they are essentially break-even enterprises. It's a bit like filmmaking: exhibitions are productions and we have to find the right context, the appropriate ~~loopholes~~ in which to realize them.

Where do you locate "do it" within this trajectory? It is your largest project to date, having traveled to over forty international locations since its inception in 1993.[13] The project asked how an exhibition can exist merely as a set of instructions and was conceived more as a call to arms for a hypothetical schematic —do-it-yourself—than as an explicit curatorial statement, per se. Could you discuss your initial objectives for this undertaking and how they've evolved? What kind of "loopholes" did you have to mediate to achieve these objectives?

Interestingly, the preeminent challenge encompassing "do it" concerned how to perpetuate a show that no big museum wanted to touch. You see, because it wasn't the "real" thing —because it was about instructions and interpretations, not concrete "works"—it never hit the primary institutional radar. By consequence, "do it" was a huge risk and it perpetuated only through an amazing grassroots mechanism

13. A complete chronology and description of the project can be accessed at e-flux.com/projects/do_it/homepage/do_it_home.html. This website also has an extensive archive of works and supplementary material created for, or associated with, "do it."

that ricocheted across all continents. From an economic
perspective, the manner in which "do it" produced its own
circuit, a self-sustaining distribution model, is exemplary,
and I consider this to be among my proudest achievements.
Although I've never believed the project invented anything
per se—the dense history of instruction art, from Duchamp's
Readymade Malheureux [1919] to Moholy-Nagy's telephone
pictures [1922] or any number of Fluxus projects makes
this assertion untenable—one novelty of "do it" has to do
with critical mass: as you suggest, "do it" is huge and has
incorporated hundreds of artists and thousands of accom-
panying documents. Subsequently, if we return to your
former question, one point of distinction vis-à-vis the
1960s era is that "do it" is unlimited in the sense that it
has encompassed truly planetary dimensions and is now
an online archive.[14]

But doesn't the recently published manual, do it, *modify this
reading?*[15] *Does this book not limit the model you are proposing?*

I see your point but disagree. This gets back to the idea
of inventing organic circuits, of "complexifying" our notion of
what a project or exhibition is. I would argue that the book
is only the most recent manifestation of "do it," one of many
possible appearances worth investigating; it's another *layer*,
if you will. In total, there are eleven "do it" catalogues plus
the e-flux online version, the latter of which spurred the
new book with Revolver and e-flux. Hence, if Siegelaub
always started with a closed artist-list and agenda—*this
is the exhibition and this is how we disseminate it*—"do it"
abandoned this model. I don't intend this as a criticism of
Siegelaub—his projects were the most revolutionary
and far-reaching in his era, but "do it" never proceeded
through a top-down plan. Rather, it was algorithmic, an
"open score" that just popped up wherever interest surfaced,

14. For further reference, see e-flux.com/projects/do_it/homepage/
do_it_home.html.

15. Hans Ulrich Obrist, ed., *do it*, vol I (New York: e-flux; Frankfurt
am Main: Revolver – Archiv für aktuelle Kunst, 2004).

like in Bangkok [1997] when this energetic group of young artists appropriated the theme and profoundly redirected it. Some of the issues this project raised, such as access, transmission, mutation, infiltration, circulation, and distribution—~~the exhibition as a learning system with feedback loops~~—have cycled back into later shows, informing "3'," for example.[16]

Could we situate these projects in terms of your general negotiation of the art economy? I would like to focus on the concept of "circuits," an idea you have highlighted on several occasions, and one that has begun to emerge at the heart of some insightful literature on the art market. For instance, Olav Velthuis has recently analyzed the contemporary art trade not merely in terms of nominal sales figures (as is the case with the majority of journalists and economists), but as an elaborate merging of actors representing different economic circuits—what he calls "circuits of commerce." This subject is especially pertinent because as investment activity accelerates—a trend that can be gauged by observing escalating corporate affiliations with the arts and the rising volume of contemporary art fairs and, in particular, art funds—economic circuits seem to converge: short-term business objectives (the investment circuit) appear ever less distinct from what are otherwise supposed to be long-term gallery-collector-artist interests (the art world circuit). I highlight Velthuis because until we understand how these circuits function, we'll never comprehend the complexity of art collecting. Have you considered your own mediation of circuits in these terms?[17]

Something I've repeatedly stressed is my motivation to enhance the pathways or circuits within which art circulates. "do it," for example, is not offering another art economy, and it's certainly not proposing that an artist can pay rent through such an experimental project. Hence,

16. "3'" ("three minutes") was co-curated by Hans Ulrich Obrist, Max Hollein, and Martina Weinhart for the Schirn Kunsthalle Frankfurt (September 2004–January 2005). See: *3'*, exh. cat. (Frankfurt am Main: Schirn Kunsthalle, 2004).

I've always regarded "do it," "Point d'ironie," and most of my other initiatives as complementary to the gallery/museum system—a system whose possibilities I'm driven to test. <u>Félix González-Torres once told me that revolutions can also be a waste of energy</u>. So, "do it" advances with traditional exhibiting institutions or networks as a given and asks how else we can add to these. It's a knowledge-production exercise, an experiment-in-progress.

Did any "do it" contributions particularly strike you?

In terms of your interest in the art economy, Michelangelo Pistoletto and Erwin Wurm had innovative proposals. Pistoletto said that if an institution wants to keep his instruction as an artwork, they must wire him $3,000 and subsequently destroy the instruction [*Sculpture for Strolling*, undated]. Or Wurm's instruction was to take a Polaroid, with the catch that if you sent it to him with $100, he would sign it and then you would have an official Wurm piece.

It appears that Wurm and Pistoletto were toying with the construction of authorship: What contextual parameters— a signature, say—consecrate something as an "artwork"? Siegelaub and his artists, not to mention Yves Klein, Manzoni, Duchamp, and the Dadaists before them, have tested similar boundaries, cumulatively questioning what the art collector is acquiring. This is a loaded query, however, one certainty is that the art economy is not merely a depot for tangible goods, as you previously remarked, but so too a sophisticated arbiter of symbolic meanings and services. Miwon Kwon has recently argued that the "performative aspect" of an artist's operational

17. Olav Velthuis, *Talking Prices: Symbolic Meanings of Prices on the Market for Contemporary Art* (Princeton, NJ: Princeton University Press, 2005). For additional reading on "circuits of commerce," see Viviana A. Zelizer, *The Social Meaning of Money: Pin Money, Paychecks, Poor Relief, and Other Currencies* (Princeton, NJ: Princeton University Press, 1997); Viviana A. Zelizer, "How and Why do We Care about Circuits," in *Accounts: A Newsletter of the Economic Sociology*, Economic Sociology Section of the American Sociological Association, vol. 1 (2000): 3–5.

mode is a "new art commodity," while authors like Velthuis have illustrated the considerable extent to which interpersonal relationships and flexible give-take accords amongst collectors, dealers, and artists impact the manner in which art transactions are executed.[18] In light of this and because your own activities are often difficult to differentiate from the artists whom you collaborate with, I wonder how your curatorial activities are compensated? I've heard that other successful curators have begun to accept commissions from private collectors. Let us recall Daniel Buren's prescient reaction to Harald Szeemann's directorship of Documenta V [1972] that the exhibition had become a "tableau" and its author, the "exhibition maker."[19]

First of all, I have only curated for Kunsthallen and museums, mostly publicly funded ones.[20] Obviously, I've also curated biennials and triennials, <u>but I've always promoted the idea of art as "elite for the masses."</u> Interestingly, I've worked very little with the public art commissions that were important in the 1980s but have become less relevant for my generation. Liam Gillick recently emphasized that a renewed focus on public art could be progressive: to reinvent public art?[21]

In terms of your second question, I should stress that I've never considered myself to be an artist. Confusion here arises <u>because I've always been close with artists who think of the exhibition as a medium</u>. But underlying this is my role of facilitating, rather than creating their projects.[22] Philippe Parreno's "Alien Seasons" exhibition [2002] that I organized at the Musée d'Art moderne de la Ville de Paris offers an excellent example: here, Philippe subverted the traditional form of a "retrospective,"

18. Miwon Kwon, *One Place After Another: Site-Specific Art and Locational Identity* (Cambridge, MA: MIT Press, 2002), 46–47.

19. The original quotation is from "Exhibition of an Exhibition" (Buren, 1972); it is cited in Daniel Buren, "Where are the Artists?" in *The Next Documenta Should be Curated by an Artist*, ed. Jens Hoffmann (New York: e-flux; Frankfurt am Main: Revolver — Archiv für aktuelle Kunst, 2004), 26.

20. A Kunsthalle is an art institution that, unlike the traditional museum, does not maintain a permanent collection, and unlike the Kunstverein does not have a membership.

inventing new display features and sign codes that did not regurgitate old works so much as inaugurate a new type of exhibition choreography. In earlier generations, Richard Hamilton and Daniel Buren were similarly oriented and certainly among the most articulate figures to conceptualize this domain—not withstanding those that you've just mentioned, and others still. The history of utilizing the exhibition as a medium is extensive, and I only wish to suggest that as curators and artists—or whomever else—experiment with time/space protocols concerning how, where, and when a work is manifested, boundaries between these actors are bound to merge. I maintain, however, that I am above all a catalyst, a junction-maker, in this chain.

Since your debut in the early 1990s, the economic stakes of exhibition-making have risen dramatically. Have you advised any corporate collections? I'm equally interested to learn about the financial or administrative responsibilities you have under-taken to secure the production of your projects.

I have been on boards of companies such as EVN [Energie-versorgung Niederösterreich], the Austrian electricity concern, and the FRAC [Fonds régional d'art contemporain] But the former was a curatorial board—a think-tank of sorts—while the latter was a collection advisory position I held only for a half dozen years in the mid-1990s.

Do you find private patrons getting more involved at the institu-tional level?

In Europe, definitely, but this has been the American way for some time.

21. Liam Gillick, "Claiming Contingent Space," in *Curating with Light Luggage: Reflections, Discussions and Revisions*, ed. Liam Gillick and Maria Lind (Frankfurt am Main: Revolver – Archiv für aktuelle Kunst, 2005), 77–88.

22. A useful, though not exhaustive, overview of this topic is provided by James Putnam, *Art and Artifact: The Museum as Medium* (London: Thames and Hudson, 2001).

I suppose this reflects the ongoing privatization of museums and art institutions?[23]

Fundraising has become elemental to the curatorial repertoire: to raise the budget of one's exhibition is key in terms of securing the continuation of programming autonomy. The American model often leads to a dependency on the trustees who finance the museum. Meanwhile, the model pursued by many publicly funded European museums has led to the dangers of new political dependencies. To reconnect to the beginning of this discussion, it is interesting to think about a "third way" between the European and American systems capable of recombining positive attributes of the two, ultimately striving to preserve this autonomy of programming. Ida Gianelli's directorship of the Castello di Rivoli [Turin] offers an excellent example of how these negotiations can be successfully approached: the museum is part public, part private, and it implements a proactive system of checks and balances to mitigate conflicting interests. I'm very interested in how we best do so without compromising the quality of exhibitions. It's key to maintain the institution's independence of programming.

What about the quality of collections? Have you been involved in the acquisition process at ARC?

Each curator at the museum can propose works for acquisition. A board headed by the museum director then decides what is bought for the collection. <u>To date, I have not been strongly involved in these processes, but in exhibitions, ephemeral statements that tend not to be collected</u>. However, in trying to reinvent exhibition formats, I've begun to appreciate the valuable role of archiving and would like to experiment with this down

23. On privatization in the art world, see Mark W. Rectanus, *Culture Incorporated: Museums, Artists and Corporate Sponsorships* (Minneapolis: University of Minnesota Press, 2002); Chin-tao Wu, *Privatising Culture: Corporate Art Intervention since the 1980s* (London: Verso, 2003).

the road. Since the late 1990s, I've tested various aspects of large-scale shows ("Laboratorium" and "Cities on the Move"), monographic shows and shows in historical and house museums where one would not expect to find contemporary exhibitions.[24] In other instances, as with the museum in progress or "Point d'ironie," I've tried to tweak the manner in which content reaches the viewer —*it travels to them*—while in virtual exhibitions like "do it," the content remains to be actualized. The virtual shows, obviously, do not concern objects and so possess an interesting affinity with time-based exhibitions such as the opera Philippe Parreno and I are curating for Alex Poots's Manchester International Festival of New and Original Work [Summer, 2007].[25]

As nothing remains of all this but books and documentation—or sometimes a *libretto* according to which a show can be restaged—I think it could be interesting to eventually reinvent the notion of a public collection; toward collections which are less about single objects than constellations, about collections of exhibitions. In terms of grand ensembles, it would be interesting to press the frontier of how non-objects and quasi objects trigger new forms of sustained long-term situations. The Dia Foundation did this in a formidable way with [Walter] de Maria's *Earth Room* [1977], for example.[26] The main problem is the moment a curator starts to think too much about the collection of his or her home museum, it influences, and even compromises, the projects therein. All of a sudden,

24. Since 2001, Obrist has curated a number of monographic shows at ARC/Musée d'Art moderne de la Ville de Paris including those of Doug Aitken, Pierre Huyghe, Steve McQueen, Philippe Parreno, Anri Sala, and Rirkrit Tiravanija. See v2asp.paris.fr/musees/MAMVP/expositions/archives.html. Obrist's exhibitions in historical and house museums include: "Gerhard Richter," Nietzsche Haus, Sils Maria, Switzerland, 1992; "Retrace Your Steps: Remember Tomorrow," Sir John Soane's Museum, London, 1999–2000; and "The Air Is Blue," Casa Luis Barragán, Mexico City, 2002–03; and "Everstill," Casa-Museo Federico García Lorca, Granada, 2007.

25. "Il Tempo del Postino" was presented at the Manchester Opera House July 12–14, 2007 as part of the Manchester International Festival. It was co-curated by Obrist and Philippe Parreno.

work gets shown with an eye toward future acquisition and you risk weakening the quality of exhibitions. Exhibitions are exhibitions, everything else is everything else ...

I'm interested in the after-life of exhibitions, in what happens to the show after its public manifestation has expired. In conversation with Cedric Price, you observe that "there is a strong amnesia with regard to exhibitions because they are not objects to be collected." [27] But you seem here, at least hypothetically, to indicate otherwise. Can exhibitions be collected?

It happens rarely but there are some examples. I've recently discussed this topic with Buren who conveyed how in the 1970s he convinced the Belgian collector Herman Daled to collect only his works for one year. They stuck to the plan and at the beginning of the following year, Daled flew to Berlin and bought a whole Lawrence Weiner show. A more recent example is Philippe Parreno and Pierre Huyghe's "No Ghost Just a Shell" [2000–02]. Upon purchasing the rights to a *manga* character ["Annlee"] from a Japanese film development agency, Parreno and Huyghe distributed her image to over a dozen artists and artist groups who created artworks based upon her. These projects were variously exhibited over three years and have since been acquired by the Van Abbemuseum, a public museum in Eindhoven.[28]

Is there a relationship between these projects and the manner in which "Utopia Station" has churned from one context to the next? [29] Have you considered how the latter might be preserved or collected?

These are relevant enquiries, but for such a sprawling group show, the questions are, again, different. After its debut in

26. *The New York Earth Room* (1977) has been on long-term public view since 1980. The work was commissioned and is maintained by the Dia Art Foundation. It is located at 114 Wooster Street, New York.

27. Hans Ulrich Obrist, "Interview with Cedric Price," in *Cedric Price, Re:CP*, ed. Hans Ulrich Obrist (Basel: Birkhäuser, 2003), 77.

Venice, and more recent iterations in Munich and Porto Alegre to name but two, Molly Nesbit, Rirkrit Tiravanija, and I have received offers to take it to New Zealand, Argentina, and elsewhere. However, this concept of transferral is increasingly complex because the show has mutated so drastically with each appearance: in Venice it was immense—over 160 artists' projects at the far end of the Arsenale—whereas in Munich the content was densified and gained coherence around the tower designed by Rirkrit. In fact, by the time it hit the World Social Forum, "Utopia Station" had essentially become a public intervention in the form of a city-wide poster project and numerous video, radio, and performance programs. I mention this to stress that this show never

28. ("... and Rosa de la Cruz, a private collector in Miami.") Before its termination, all the works created for "No Ghost Just a Shell" were exhibited in a show at the following three venues: Kunsthalle Zürich (August–October 2002); Institute of Visual Culture, Cambridge (December–January 2003); and Van Abbemuseum, Eindhoven (January–August 2003). For further reference on the project, especially the legalistic apparatus determining how it evolved and has since been collected, see *Pierre Huyghe/Philippe Parreno: No Ghost Just a Shell* (Cologne: Verlag der Buchhandlung Walther König, 2003).

29. A full-scale version of "Utopia Station"—replete with poster project, public discussions, film, radio and video programming, and art installation—debuted at the 2003 Venice Biennale (June–November 2003) and was reformatted at the Haus der Kunst, Munich (October 2004–January 2005). The poster project and related artist/curator-led initiatives occurred in conjunction with the World Social Forum, Porto Alegre, Brazil (January 2005). The posters and various elements provided by both the "Utopia Station" team and local organizers have been exhibited as follows: Haus der Kunst, Munich (September–November 2003); KUNST+PROJEKTE Sindelfingen and the Gallery of the City of Sindelfingen, Germany (November 2003 –January 2004); and Avenir de Villes, Nancy (May–August 2005). Stand-alone talks relating to the project have occurred in Poughkeepsie, New York (February 2003), Das TAT (Theater am Turm), Frankfurt am Main (April 2003), and Princeton, New Jersey (March 2006). The 158 posters commissioned for "Utopia Station" are permanently on view and available for download at e-flux.com, a site that also serves as an excellent reference for specificities of the various iterations noted above. For further reference, see also Molly Nesbit, Hans Ulrich Obrist, and Rirkrit Tiravanija, "What is a Station?" originally published in *Dreams and Conflicts—The Dictatorship of the Viewer*, exh. cat., The 50th International Art Exhibition—La Biennale di Venezia (Milan: Skira, 2003), 327–336.

shifts in one-to-one ratios, the benefit of which is a singular production of commentary on the chosen topic.

Such holds for many exhibitions, though. "Cities on the Move" arguably created an even greater range of material on its subject, the global city.

Perhaps. But I think we should return to your idea of what it means to collect such an exhibition. I would suggest that it's not only about collecting artworks, but the eventual constitution of archives capable of sustaining future knowledge production. This was something we first encountered with "Cities" and after it dispersed and toured for several years, we donated and consolidated it as an archive at Iniva in London, a site which now functions as a library for researchers of the exhibition.[30] But the "Cities"—an Iniva venture is only one possibility of the type of endeavor I'm contemplating. After Munich, for instance, Molly, Rirkrit, and I considered having both a permanently changing exhibition all over the world and a fixed, local "station" to which the show could be forever indexed. We thought this might revolve around the tower, to which we could send documentation as the project evolved.

So, you would maintain an ongoing archive?

Yes, but it is an unrealized project: the tower's original conception in the Ehrenhalle did not allow it to be meaningfully relocated. Nevertheless, these deliberations point to how exhibitions may be collected in the future.

And, again, they appear to complicate short-term art trading gambits.

Absolutely. One way to address this is via Félix González-Torres, a master of the time-based exhibition, from whom

30. Iniva is located at 6–8 Standard Place, Rivington Street, London EC2A 3BE. For further information on the institution and the "Cities on the Move" archive, see iniva.org.

I learned enormously at the beginning of the 1990s. <u>Félix</u> <u>was resolute in insisting that the institution has a long-term</u> <u>obligation to care; that it's not about acquiring an object,</u> <u>but a contract with which a collector then engages—it's an</u> <u>engagement.</u> <u>It's like flowers: if we don't tend to them, they die</u>.

That blends elegantly with something that <u>Liam Gillick</u>, a principal accomplice of yours in "Utopia Station," told me when I asked him about his own relationship to the marketplace: <u>the best collectors,</u> <u>he said, are those who buy time</u>.[31] *As you suggest via González-Torres, we're not talking about tangible investments—although objects inevitably circulate—but investments in a career, an idea. There seems to be a longing for wholly traditional forms of patronage ...*

Concerning the exhibition, itself, we need to part with the conception of the institution as the absolute center; it becomes more a relative center, like a hyper-knot with tentacles. Chris Dercon [Director, Haus der Kunst] under-stood this: in hosting "Utopia Station," he was exceptional both in facilitating the on-site production and in opening up regional links in and around Munich—the German Academy of Art, the radio, newspapers, etc. After this come questions pertaining to the exhibition's "limited" life span.

This is something you presumably absorbed from Cedric Price? You were greatly influenced by his idea that buildings need not be permanent, that they could be erected with an awareness of their eventual destruction.

Absolutely, and if we come full circle with "Utopia Station," we should ask how a rotating curatorship could be run. There's nothing worse than having a frozen structure of decision-making. So, the vision, the physical apparatus sustaining "Utopia Station," should transform and enable the eventual creation of a place where all the exhibition software—the videos, conversations or tapes, *not objects* —

31. Author's interview with Liam Gillick on August 9, 2004.

could coalesce. We can conceptualize this as a minimum of conditions, a place where everything can happen because nothing has to happen. It might be like the DNA for future exhibitions, or an open-source model. We really don't know. It's still too early.

Could we conclude by speculating on how the archival models associated with "Annlee" or "Utopia Station" potentially alter typical approaches to the art market? From what I gather, what we're discussing need not reconstitute the manner in which goods are exchanged, but suggests a shifting emphasis in terms of the composition of exchange: towards "lighter luggage," [❖ Cedric Price, dontstop] perhaps, if we borrow the title of a symposium in which you recently participated.

Yes, I think that's apt; the object does not stand in the way: it's about being more flexible, lighter on our toes in terms of how exhibition, collection, and archival accords are negotiated. From this perspective, "Annlee" is fascinating because although it shifts ~~the rules of the game~~, it simultaneously functions within the existing institutional system: all associated works were bought from the participating artists' galleries. The project thus avoids becoming a homogenized package and although it's now consolidated in two locations, the artists have very carefully negotiated how it is to be exhibited. If you'd like to compare this to ongoing deliberations over "Utopia Station," one fundamental difference concerns the status of artworks versus documents. Within "Annlee," this issue does not arise—every piece *is* an artwork—but "Utopia Station" forces one to consider when a document becomes a work of art and consequently how it needs to be preserved.

That theme, however, is hardly novel. If we isolate Siegelaub and the conceptualists, the interrelationship between documents and artworks—not to mention their status as commodties—has long been a pivotal topic of investigation.[32]

You're right, but I'm not sure it's ever been sufficiently resolved. Hence, another difference—and a divergence with the "Cities" precedent as well—is that we're no longer envisioning the archive as an *a posteriori* accumulation of documents, but the exhibition as an archive that can be mended *in situ*. So it's not really about Rirkrit's tower as an object, but the tower as a catalyst. In German, there's an expression that says you have one leg to stand on and the other on which to play. It's a bit like this with the kind of exhibition I'm envisioning: you have all these floating satellites, and then some kind of ...

Home?

Yeah, it's a home base. And when I think of home, it's where the books are. So in a funny way, when discussing circuits, fairs, funds, and so on, we should really widen the question of collections and relate it less exclusively to objects (~~they are, as Marcel Broodthaers said, one possibility surrounded by many other possibilities worth exploring~~) and more to continuing the engagement. We could think of this as a quest for sustained funding.

I suppose one might even regard this as a formula for better cultivating our relationship to the art market, for advancing our approach to collecting.

The ocean never dries.

32. See Alexander Alberro, 2003; and Benjamin H. D. Buchloh, "Conceptual Art 1962–1969: From the Aesthetic of Administration to the Critique of Institutions," *October* 55 (Winter 1990): 105–143.

Taxi, Paris, 8–10 pm

with Sophia Krzys Acord
December 15, 2005

Taxi, Paris, 8–10 pm

Sophia Krzys Acord — *When do you use the word "show" and when do you use the word "exhibition"?*

Hans Ulrich Obrist — I usually don't say show because it seems too much like show business. I refer to myself as an exhibition-maker.

What is the role of the curator for you? You've mentioned that it involves networking, fundraising, liaising with artists, gallery visits, etc.

Yes, those features are all part of accompanying exhibitions. The role of the curator involves a long list of duties, and this list has expanded tremendously over the past few years. Curating is now a very general profession. But to go back to the origin of the word, curating comes from the Latin *curare*, which means to take care of— artworks in this case. This has to do with the museum curator's activity, which is to protect the works of a collection and to organize exhibitions. This remains a core function of the curator's role, because most curators do work in museums and the appearance of the independent curator is a fairly recent phenomenon.

A second aspect of the profession is that an exhibition-maker is often a catalyst. The curator not only takes care of the works, but is also a facilitator in producing reality, helping to create and finish projects, and even making it possible to do projects in places that would not have been otherwise accessible. Most importantly, the catalyst has always been able to disappear. Thus, I am very much opposed to the idea of a dominating curatorial approach which ~~often stands in the way of the exhibition~~.

The role of the curator is to create free space, not occupy existing space. This returns to an idea that ~~Félix Fénéon developed in the early twentieth century, of the curator being a pedestrian bridge~~ [❖ *dontstop*]. In my practice, the curator has to bridge gaps and build bridges between artists, publics, institutions, and other types of

communities. The crux of this work is building temporary communities, by connecting different people and practices, and causing the conditions for triggering sparks between them.

In sum, a simple definition of curating is being involved in the creation, production, realization, and promotion of ephemeral situations. Exhibition-making is a temporary activity which does not produce objects. While exhibitions may seem futile in this sense, they are an extremely interesting activity because they allow both artists and architects to test reality. Take the example of architecture—~~within the architectural exhibition, architects have triggered the most interesting display features~~. Of course, then there is the recent phenomenon of the international, <u>independent curator</u>, which actually dates back to Harald Szeemann and others who pioneered this activity in the early 1960s. However, <u>it is very difficult to teach this activity. There is no ten-point plan. I spent five to seven years studying exhibitions before doing my first exhibition in 1991</u>. Yet, at the same time you're not in a completely defined field; it's quite up to you to define your role as a curator and your economy. There is no such thing as an existing economy for independent curating, and <u>I found it super difficult to make a living as an independent curator</u>. Although I've curated widely, without my permanent employment in art institutions or schools, I would not have been able to generate the continuation of my thinking and work. <u>You have to invent your own trajectory, not only in order to flourish, but merely to survive!</u>

Jens Hoffmann once told me that he feels that every curator has a signature to his or her exhibition-making—he can recognize the curator from the style of the installation, for example. Would you agree? If so, can you tell me about your signature?

Every curator certainly has a different approach, methodology, set of rules, or mechanisms. In this sense,

Jens is right. However, I'm hesitant to say that there is a specific signature to exhibition-making because I don't think the curator should impose a signature; the curator should not stand in the way. So, I would say that a strong proximity to artists is what connects all my projects.

I suppose this also has to do with that notion of star power, that the curator puts their mark on the exhibition.

I believe it's not true in my case. I always try to do the opposite. In a Picabian way, I like to surprise people by inventing things that nobody would expect. What is interesting is to permanently change the way we work; otherwise we risk our work becoming predictable. This is the famous *étonnement* which Cocteau was involved with earlier in the twentieth century when working with the Ballets Russes—the whole idea that you must always be able to surprise others, and to be surprised yourself.

I've worked on a panoply of different exhibitions, including reinventing the monographic show, all kinds of group shows, very large exhibitions, new models of exhibitions, self-organizing exhibitions, etc. Understandably, this spawns the existence of many dialectics, tensions, and dialogues between these different spheres of work. Some may say that this is precisely my style—that the absence of style is my signature.

I prefer to not be in the center of things. As Deleuze said, it is dangerous to occupy territory, because the moment you believe in power and, by extension, that you have power, the work you do becomes uninteresting. Instead of a frozen signature, I view my existence as a *flânerie* of sorts. I've always believed in avoiding the routine, and constantly reinventing new sets of rules and methods of working. Curiosity is the main constant in my practice.

One of the most pressing issues in the sociology of art is the question of publics for certain art forms, especially when the consumption of contemporary art is stratified along class, gender, age, and other lines. How do you envision your public?

This is a huge topic, of course. There is no one homogenous public. I believe that through the exhibition, ~~the curator builds hundreds of pedestrian bridges~~ to hundreds of communities who then converge and create new encounters through the exhibition. Of course, this implies a tremendous amount of educational work and public programming, often involving artists as well, which blurs the main and secondary functions of the museum. Where you do an exhibition is not self-evident because you must always think about the placement of the exhibition in order to foster dialogues.

To return to the idea of the curatorial signature, having a signature means that you have a master plan from the outset. My practice is constantly oscillating between order and disorder. ~~As James Cameron, the film director of *Titanic*, once said, "Making a movie is always slightly against entropy~~." Making an exhibition entails the same struggle. Thus, questioning authority (even curatorial) has also always been at the heart of my practice; hence introducing self-organizing models and creating exhibitions within an exhibition.

This idea also stems from my experience with urbanism. In the 1950s, many urbanists questioned Le Corbusier's master-planned structures, and began to redefine negotiations with the local and the global. I have been greatly influenced by urbanism, namely by Cedric Price's non-plan, Yona Friedman's amazing capacity of self-organization, and Oskar Hansen's open form. This influence is ongoing. With the Guangzhou Biennale, which Hou Hanru and I curated in China last week, we invited a variety of artist-run venues from across China to curate individual spaces. They invited their own artists, and while we followed their work and offered support, we were surprised ourselves on the day of the opening.

If part of your role as a curator is to oversee the exhibition, how do you deal with this whole idea of "not knowing"?

We obviously knew they were high-quality, artist-run spaces; otherwise we would not have given them *carte blanche.* We had to trust them. Of course, we also visited their spaces and looked at many other spaces. We did this with Laurence Bossé in "life/live," as well. So, in this sense, there are exhibitions within the exhibition. Again, as a curator, I had long tentacles, or ~~pedestrian bridges~~, between these different communities and spaces. ~~That seems pretty distant from the idea of a signature; in this sense I am the anti-signature curator.~~

I want to ask you about your repeated use of postcards. Many of the publications from your early exhibitions, such as "Hotel Carlton Palace," are composed of postcards.

I worked with Kasper König early on and he has a huge postcard obsession; he is always sending amazing postcards to his friends while on various journeys. But what really triggered my use of postcards was seeing all of these publications from the 1960s done with postcards from Lucy Lippard to Maurizio Nannucci. This implies that the publication is not a secondary, redundant product that will end up in the garbage. Additionally, a postcard is another opportunity for the curator to disappear and give an artist *carte blanche,* because the postcard is a work of art. In this way, the publication becomes a primary space, the extension of the exhibition into printed space or some other form of dissemination.

It also seems that because the exhibition is, as you said, temporary, the catalogue is very important in disseminating it somehow into the public space.

There is a visible publishing obsession within the art field in general, not just in curating. I think this is relat-

ed to the rampant existence of self-organized and small publishing initiatives. While I have a compulsion towards collecting books (I buy at least one book each day), I also want to produce or edit one book every day. Obviously I don't really succeed, but perhaps every two or three days! Today, the book is an implement, as well as a tension, because I have all of these heavy books to carry around. For me, publishing is not limited to exhibitions; I see books as an additional curatorial space.

The curator also seems to be a translator of sorts, between funders, artists, institutions, and politicians.

In a way, the curator negotiates between the different realities and fields implicated in exhibition-making. Indeed, there have been periods when I have wondered whether I could spend my whole life in the art world or whether it was too narrow to be in one field. As a result, I constantly ventured into other geographies (like with "Cities on the Move" or the Dak'Art Biennale) and other disciplines. For example, my science research is evident in "Bridge the Gap," "Laboratorium," and "Art and Brain." In addition, ever since "Mutations" and "Cities on the Move," I have retained a strong tie to architecture and urbanism, which now continues through my involvement with *Domus*. But, I never left the art world. There have been ~~moments when I doubted the art world, but then I met artists like Carsten Höller, who informed me that the art world is the least bad of all worlds, because it permits this enormous degree of freedom~~ that allows you to make these external connections. So, I never want to leave the art world, only widen it perhaps.

I agree with what ~~Alexander Dorner~~ said in the early twentieth century, that if we want to understand the ideas and processes which are effecting visual culture, then we must ~~understand what is happening in other fields of knowledge,~~ such as science and architecture. Only then can we understand the art of our time. As for myself, I'm

astrologically a Gemini, and as Dan Graham pointed out, Geminis have an insatiable curiosity about the world. Indeed, I originally studied economics in order to better understand the world. By spending time in all of these fields, I develop new alliances.

You talk quite a bit about the "research" that you conducted for several years before doing an exhibition. How do you turn research into an exhibition, such as with "Cities on the Move"?

Research and the exhibition are never separate, but always develop in parallel. The research is the exhibition and the exhibition is the research. With "Cities on the Move," everything began on day one. We traveled with Hou Hanru across Asia for several months. On the way, we invited practitioners and began building the project together. Then we continued the research and opened it up again. I try to allow a certain degree of improvisation, while being super organized at the same time.

I want to go back to my earlier question about publics— how do you physically work to integrate new publics into the art world?

I've never been interested in just curating for the art world. The art world is my home base, but I pursue an expanded notion of curating. This necessitates permanently testing the limits of the art world, by building "passerelles" [see Félix Fénéon] to many different communities within and beyond the world of art. As I've been in the art world for over twenty years, rather than renouncing it, my venturing into other fields constantly refocuses and returns to it fresh.

 I would never prescribe this means of operating to other curators or curatorial students, because I think that everyone has to find his or her own way. That is the best a teacher can do: see what's within people and then encourage movement. The last thing I think that

a teacher should do is to try to prescribe models. When you move into another sphere of working, it is not an exercise of unilateral transfer or appropriation, but rather about creating reciprocity and contact zones.

One enemy in the art world is overexposure, something that Bruce Nauman pointed out. ~~I try to be in the middle of things, but not in the center~~. I've turned down some large-scale shows, so that I can continue working without becoming paralyzed. So, by visiting other worlds of operating, I manage to work in waves, from the center to the periphery of the art world. The inherent danger with this activity is like what the North Vietnamese ~~General Giap~~ said, recounted by Mario Merz in his famous neon, *Giap's Igloo*: ~~when you win territory, you lose concentration~~. In other words, when you find yourself very widespread in the territory of your work, you risk losing your focus. So, I constantly engage myself in focused projects, such as the opera I am currently doing with Philippe Parreno, or my Lorca project linking art and literature at the Federico García Lorca Foundation in Granada. Both projects build bridges that integrate a polyphony of new publics.

It's Alive

with Paul O'Neill
Paris, 2004–06

Paul O'Neill — *In the last fifteen to twenty years there has been an unprecedented interest in contemporary art curating. How do you think curatorial discourse has changed during this period, and what are the dominant forms of curatorial practice that have developed during this time?*

Hans Ulrich Obrist — The field has grown exponentially in the last years. One of the main changes is the emergence of many new biennales. The ever-increasing polyphony of centers is another major change; also a multitude of curatorial models have emerged. The last fifteen years have seen the appearance of a very strong generation of artists who have put the focus on the time protocol of exhibitions, which has led to a whole new form of exhibition: the exhibition as a program. A major change has also happened in the funding. In the early 1990s, curating involved a whole range of activities—Szeemann's famous list of the curator as a generalist. However, fundraising did not play a big role. <u>But ever since the second half of the 1990s, fundraising has become an essential task of a curator. The exhibitions I have organized since 2000 would not have been possible without massive fundraising</u>.

Something very apparent in your projects is an interest in establishing exploratory spaces or laboratories without finite statement. You appear more interested in contributing to knowledge, producing something that can be used elsewhere. This can be seen with your exhibitions "Interarchive," "Laboratorium," and even "Utopia Station." There are so many models being used within the same framework, and with the Interviews project there is the same ongoing production of information for other people to use. You work with many people over a long period of time where you employ people to do a particular task. Your projects span a wide field of discourse, and it seems that as a kind of admission that you may not know it all, you bring people with knowledge on board to assist in the research and realization of projects. How important is this pooling of knowledge to you?

Generally speaking, I have always tried to avoid exhibitions that illustrate a curatorial proposal, which I think is a redundant and very limited concept. My first curated show, "The Kitchen Show" in 1991 in St. Gallen, was about testing the kitchen as a place for an exhibition, following Robert Musil's dictum: "Art happens where we least expect it." It was not a kitchen theme show. With regard to the laboratory projects you mentioned, which are all long-term, the "theme" of the show has to be a trigger. The idea of the exhibition space as laboratory enables the unexpected, the spontaneous, and the unplanned, as in "Cities on the Move," "do it," or "Laboratorium," which didn't follow a top-down plan. This is where curating can learn from urbanism: to question the oft-unquestioned master plan. Yona Friedman, Constant, Cedric Price or Team X all questioned the master plan in CIAM X, Dubrovnik [Congrès International d'Architecture Moderne] during the 1950s and tried to use bottom-up organization. "Cities on the Move" [1999] evoked the visionary manifestos about open form and participation of the Polish urbanist and architect Oskar Hansen, who died earlier this year. For "Cities on the Move," Hou Hanru and I tried to use the traveling show, which is usually a homogenizing force. We tried to do the opposite and produce a local and global research system for each venue. It was a continuous process of dialogue, of emerging collaborations, feedback loops, and notions of circularity, also of *mise en abîme* and recycling of previous exhibition designs. With "Utopia Station" [2003], Molly Nesbit, Rirkrit Tiravanija, Liam Gillick, and I wondered how we could think again about the social contract of art. After an initial appearance at the 50th Venice Biennale in 2003, the Station has developed into a kind of evolving system. From being a very horizontal concept in Venice, it was transformed into occupying a "receptive" zone, which can at any point be activated again. In view of this, we decided for the installation of "Utopia Station" at the Haus der Kunst in Munich to develop more of a program.

The entire piece, an architectural display feature by Rirkrit Tiravanija, is a vertical tower built from recycled materials, which is not a building but a passage to walk through, with zones for projections, light zones and dark zones, fast lanes and slow lanes. The space is programmed in a different way every day.

Something these laboratory research projects have in common is that there are different layers of involvement for the artists: some contribute a work, but often a new work is triggered, and others contribute structural elements for the installation or exhibition architecture. In order to understand the forces that are effective for the visual artist, it is necessary to look at other fields, not just artists but architects, designers, writers, ~~in order to create a pooling of knowledge~~. I think a curator should not stand in the way. This is my idea of curating: not only to ask the artist to do a piece, but to get involved in a different, often more intense, way. This started with my kitchen show in 1991, when ~~Fischli/ Weiss made a kitchen altar~~ and produced all the photographic documentation of the show. This is a leitmotif.

You have said that "routine is the enemy of the exhibition."

It is always interesting for an artist or architect, or a museum, when practitioners are asked to do something they wouldn't normally be asked to do. It is Cocteau and Diaghilev's "Étonne-moi." I have been inspired by this, explicitly by pioneers ~~such as Alexander Dorner, Willem Sandberg~~, or Adriano Olivetti and their experiments. Another thread of the laboratory exhibitions that you mentioned is the idea of inviting architects and scientists to participate in these projects. In the art world, ventures into these other fields happen regularly. Contact with architecture and urbanism has become particularly intense with projects such as "Cities On the Move," "Mutations," and more recently, *Domus* magazine with Stefano Boeri.

Concerning your initial question, I see the archive not as a continent but as an archipelago. [✻ *dontstop*].

The title "Interarchive" has a double meaning: it is an archive between cities on the move and not belonging to a geography; it is also about in-betweeness, the zones between other archives. An archive always hides another archive, which leads us to the "Utopia Station" project, the idea of archives of exhibitions. ~~Besides curating, I also developed the "Interviews" project~~.

As toolboxes, the exhibitions that you have done incorporate the idea of the exhibition developing over time. "Cities on the Move" had various manifestations; "Utopia Station" and "do it" are both ongoing projects. How would you see your projects as toolboxes? How do you see them as possibilities for ideas being filtered through those projects and into the curatorial projects of other curators?

There is something lifelike about shows like "do it" or "Cities on the Move," and the way they tour is more that they have their own life cycle. The exhibition is alive. Lynn Margulis wrote: "Metabolism has been a property of life since it began. The first cells metabolized. They used energy and material from outside to make, maintain, and remake themselves." Scientists in the early twenty-first century are inventing a future based on molecular technologies, from biotechnology to nanotechnology to material science. Then we could also talk about Mandelbrot or the butterfly effect of exhibitions, which sometimes occurs ... this is something that is very difficult to plan, but I think it has something to do with it. Exhibitions have to be generous and maybe the most important thing is not exactly knowing where they will lead. This is something we are always trying to define so it can be used by other fields.

The preparation and research period for large-scale exhibitions has decreased dramatically with the expansion of biennial culture and the acceleration of art's global economy. How has the issue of temporality affected your practice and research as a curator of these shows?

The homogenizing forces of globalization are also affecting the art world. One important aspect is the formatting and homogenization of time. Therefore, the necessity for the coexistence of several time zones in exhibitions enables a great variety of different contact zones. I am interested in the whole notion of the time protocol of the exhibition. I am working on a larger show for 2007 co-curated with Philippe Parreno in which ~~every artist will have a different time, instead of space.~~

How does your multilayered approach to exhibitions continue with "Uncertain States of America," 2005, the show you co-curated with Gunnar Kvaran and Daniel Birnbaum at Astrup Fearnley Museum of Modern Art in Oslo?

"Uncertain States" is part of a series of shows that reinvent the problematic format of the survey in a specific scene. We are showing forty artists who emerged after 2000. Similar to the way the monographic shows work in Paris, which take the usually very rigid and predictable genre of monographic shows and try to give it a new edge, we are trying to reinvent its spatial and temporal parameters. There are many shows with a number of artists from a specific city or country, and they are usually meaningless to the artists and more about representation rather than becoming a performative space. Earlier shows—like"Nuit Blanche," "life/live," which I co-curated with Laurence Bossé (under the direction of Suzanne Pagé)—were about scenes in the UK and Northern European countries in the 1990s, and now "Uncertain States of America" is the outcome of a long research period. It focuses on a specific geography. Gunnar [Kvaran], Daniel [Birnbaum], and I traveled to the US eleven times for research this year, visiting Seattle, Portland, Chicago, Pittsburgh, Miami, San Francisco, as well as New York and other places. In Europe, we are usually only familiar with New York and, to a certain extent LA, and the other scenes are neglected.

The show tries to illustrate the complexity of a new generation. For the first chapter we have individual

presentations, almost like shows within a show, temporary autonomous spaces where the artists' singularity is the focus. The artists each have a room and show an ensemble of their work or a bigger installation. It is interesting to see that there is a strong emergence of political work, many works are about open-ended, nonlinear storytelling. There is also a strong presence of non-nostalgic ways of revisiting pop. The artist Matthew Brannon designed the catalogue and all the related printed matter. The show opened last week and we already have six venues where it will tour so the research can go into more depth in the years to come; each show will add a new chapter.

Your expansive large-scale exhibitions are often the most well known, but since the 1990s you have been working on solo projects with artists as part of the "Migrateurs" project at the Musée d'Art moderne de la Ville de Paris, and more recently, you have been developing long-term monographic projects with artists at the museum. Are they testing the parameters and potentialities of what a monographic show could be?

The idea of the shows for Musée d'Art moderne de la Ville de Paris was to reinvent the often rigid format of the monographic show. At the same time, this is something which has become a recurring theme. First of all, they invent a ~~new display feature~~ to show the work. As Richard Hamilton once told me: "~~we will only remember exhibitions that invent a new display feature~~, another aspect." We invite the artist to take over parts of the museum for a big solo show, a monographic space, and at the same time invite him or her to invite other practitioners with whom they always wanted to work. For example, with Philippe Parreno we made contact with Jaron Lanier, the inventor of virtual reality, who wrote the program for Philippe's show. Each time the fish appeared a projection popped up like a pop-up book, and at the same time there was a collaboration between Philippe and François Roche. We also put Olafur Eliasson

in touch with Yona Friedman, who did a floating city; we did an experiment with Luc Steels, and with Steve McQueen there was the whole story with NASA and William Clancey from Voyager.

In the case of Rirkrit Tiravanija's retrospective, which we co-organized with the Serpentine Gallery and the Museum Boijmans Van Beuningen in Rotterdam, it was Tiravanija's desire to involve science-fiction writer Bruce Sterling to write a script for the show. The next shows in this series are Doug Aitken, Pierre Huyghe —who is in dialogue with the novelists Frederic Tuten and Alain Robbe-Grillet—and Karen Kilimnik; then Cerith Wyn Evans will have a retrospective while collaborating with the composer Florian Hecker.

You have been an advocate of both Bruce Altshuler's The Avant-Garde in Exhibition *and Mary Anne Staniszewski's* The Power of Display, *which are quite key, not only in looking at amnesia within the history of exhibitions, but also locating the laboratory years within contemporary curating. Do you think these two books are the beginning of the historicization of curating?*

~~There is a missing literature of exhibitions~~. At a moment when there is so much talk about curating, there is very little literature. We have to start with ~~Alexander Dorner in the 1920s~~ in Hanover, then ~~Willem Sandberg in the 1950s~~ in Amsterdam, or even Pontus Hultén—most of their books are out of print and often not accessible in English. Sandberg inspired the generation of Szeemann, Hultén, and so on. There are very few examples and that is why they are so welcome, so important. It has a lot to do with the fact that ~~exhibitions are not collected~~ and that's why they fall even more into amnesia. This is the main part of the interview project, to write an oral history of exhibitions that asks scientists, artists, and architects to talk about their exhibition experiences. We should also take into account that architects are great curators. I believe we should look at curating at large,

which also means unexpected curatorships: architects as curators, or scientists as curators. Peter Galison from Harvard has fabulous ideas about curating science from which we can learn.

When Barbara Vanderlinden and I did "Laboratorium," we invited Bruno Latour to be involved in the think tank. He curated a section called "the table-top experiment," which involved performative events on a table upon which experiments got reenacted. It was the first time he had been invited to curate something. In terms of unexpected curatorship, the main example remains "Les Immatériaux" by Jean-François Lyotard. This was what you described before: a toolbox so that many people could take things and connect with them over many years. I still have the catalogue, it is like a game of cards, like the Eames House of Cards.

You have been working with curator Hou Hanru again on the Guangzhou Triennial this year. It continues your play with expansive, transformative, fluctuating exhibition formats. How is this different from the previous Triennial?

The first Triennial in 2002 took the form of a retrospective of contemporary art in China in the 1990s. With this year's exhibition, Hou Hanru and I are connecting an international event to the context of China. Instead of making a large exhibition, we decided to do a sustained project, which will last for about eighteen months. Then, in November of this year there will be a synthesis with a larger exhibition. The projects bring seminal artists such as Dan Graham and Fischli/Weiss to China for the first time, and at the same time there are artists from all over China to show the amazing energy of the local art scene at the moment. A big potential for any biennale is to create a spark in the local scene—the biennial is a catalyst, or, in the words of Anri Sala, it can produce "different layers of input in the city."

Labomatic

with Jean-Max Colard
2002

✻

If he hadn't fallen into the art world, Hans Ulrich Obrist could have either become another Einstein or an airplane steward. He might as well have his own airline company, as this tireless globe-trotter always seems to be in between places. One could cross paths with him in Frankfurt or Hong Kong, or find him sleeping in a transit hall, always flanked by his loyal companion—a constantly connected laptop computer —checking his e-mail. This Swiss exhibition curator is also a "mad scientist," who conceives of his job as a "maker" of exhibitions, as others might be dedicated to pure research.

He looks like an obsessed mathematics student with his disheveled multilingualism (in high school, he bought La Pravda in a kiosk and then signed up for Russian language classes in order to be able to read it!), and indeed his exhibitions take on the form of a laboratory—working with artists, scientists, architects, and philosophers. With his accelerated speech running faster than my tape recorder, Hans Ulrich Obrist is not only a multi-connected UFO, he is above all, someone close to artists and who has contributed most to changing the artistic landscape of the 1990s.

"My medium is the exhibition"—and he has made all sorts: solo and group, whether taking place in his kitchen or taking over the giant film screens on the streets of Seoul; in the rooms of museums or in the sewers of Zurich. He is incessantly changing formats, durations, habits, and rules of the exhibition—this floating framework upon which the history of twentieth-century art is written. Along the way, he has discovered dozens of artists all over the world, he has imported the English and Nordic scenes to France, and he has demonstrated the incredible energy of Asia in "Cities on the Move."

His method? A continual conversation, followed up relentlessly through dozens of e-mails, interviews, and discussions with all sorts of creative minds in art today, from Douglas Gordon to the architect Rem Koolhaas, from Fischli/ Weiss to French artists—Pierre Huyghe, Philippe Parreno, and Dominique Gonzalez-Foerster—from the robotician Luc Steels to the sociologist Bruno Latour. He is attentive to the

*desires as well as the needs of artists, and in return, he
unfailingly responds to their expectations, even if he has to
break the conventions and habits of the biggest museums
in the world.*

*Traveling nonstop, Hans Ulrich Obrist has been based
in Paris for several years, which he considers the best place for
contemporary art. I had the occasion to squeeze in two hours
in his small office at the Musée d'Art moderne de la Ville
de Paris, twelve square meters of mess, under a constantly
flowing avalanche of books. And so I met this catalyst of
energy, this test tube with a thousand ideas in his head.*

<p style="text-align:center">**⁂**</p>

Hans Ulrich Obrist — There isn't a word in the French
language to describe my line of work. In German, it's simple:
I am an "Ausstellungsmacher," a "maker" of exhibitions.
In France, it's more complicated: one says "commissaire
d'expo," but that's actually the dictionary definition, and
doesn't correspond at all to my nonauthoritarian concept of
the exhibition. Or otherwise, curator, a word too medical;
or again, art critic, but that doesn't describe the same
activity. Sometimes I write about art, but it's pretty rare.
My medium is the exhibition.

Jean-Max Colard — *How did you become interested in art?
Through your parents?*

No, I come from a middle class family without any relation
to the art world: my mother taught and my father worked
as a controller. I was born in Zurich, in May 1968, a good
date (but not in Paris); May 1968 didn't arrive in Zurich
until twelve years later, in 1980. My parents lived near
Lake Constance, and I went to school in Kreuzlingen, a
sort of twin to the German city of Konstanz. We crossed
the border three times a day; and as soon as there was a
break in school, we'd go to Germany. From there, perhaps,
came my notion of travel, of crossing-over, which I have

always adopted in terms of my way of working. It was around 1982–83, at the age of thirteen to fourteen, that I started to become interested in art. I went to high school in Switzerland, and I started very early traveling between Basel, Zurich, Bern, and Geneva to see many exhibitions.

Retrospectively, how do you explain your interest in art and not the cinema or music, like other teenagers in the 1980s?

It's difficult to say ... Switzerland offers a tremendous density of contemporary art exhibitions, and so that must have been, without a doubt, one of the factors. But I also think that artists have a foreknowledge about everything surrounding us, they have an intuitive relation to the world. They are sort of masterminds of the unthinkable, the impossible, of an unstable balance, of extreme points. All at once, art offers a huge possibility for destroying the bridges between disciplines and geographies, of navigating between the what is known; and for me, art offers up the chance to learn. I love to follow the way that philosophy, for example, migrates into the art context. It then becomes the place where philosophy survives. The art world often complains about itself. But as an example, for the artist ~~Carsten Höller, who had left the world of science and research~~, ~~art is the best place to be~~.

Have certain encounters been decisive for you?

My encounters with Fischli/Weiss were important: ~~when I was in high school, I went regularly to visit them in their studio in Zurich~~, which was like a sort of parallel school. But there are also "meetings" with books, which can often be more important to someone at this age. One book on Alighiero Boetti absolutely moved me: he was the owner of a hotel in Kabul in the 1970s, and he had whole villages in Pakistan and Afghanistan working for it. He was largely forecasting questions about globalization,

and I always thought of him as a sort of European Warhol. Another book is ~~Alexander Dorner's *The Way Beyond "Art"*~~. He was a visionary personality, was very close to artists, and he was the director of the <u>Landesmuseum of Hanover</u> in the 1920s. <u>He envisioned a Kraftwerk-type museum, a real center of energy, that would be mobile, and which would serve as a model for the MoMA in New York. He permitted me to understand all the potentials of exhibitions and to envisage the museum as a "laboratory of looking."</u>

What was your first exhibition?

Personally, I never studied art. ~~After high school, I studied sociology, economy, political science~~—everything—except art! At the same time, I informed myself about art. The desire to organize exhibitions came suddenly, as I knew it was urgent and necessary, which has always remained my first question. ~~Routine is the absolute enemy of exhibitions;~~ for me, each exhibit must be made as if it were the first time and must respond to necessity and urgency. ~~How can one change the rules of the game each time? Thus, my first exhibition was made in 1991 following a series of conversations with Fischli/Weiss and Christian Boltanski, who I had met in Paris on a high school trip. We had the idea to make a show in the kitchen~~ of my studio in St. Gallen in Switzerland, tying back to exhibitions in the 1970s which took place at unusual sites. In four months, there were only about thirty or so visitors: <u>Hans-Peter Feldmann had put eggs in my refrigerator, Fischli/Weiss had placed immense food products on the shelves, five kilos of ketchup, ten kilos of pickles, etc. Boltanski had made a small projection using candles in the garbage can</u>—it was a sort of little miracle—~~art happens where you least expect it~~. [❋ Robert Musil, *dontstop*]

There was also an exhibition at the Hotel Carlton Palace in Paris ... What was that?

189

In 1993, I made a show in room 703 [previously 763, ❋
dontstop: découché?] in this slightly decaying ex-palace
on Blvd. Raspail, where Gloria Friedman, Bertrand
Lavier, and Raymond Hains all stayed, as well as some
old ladies who had lived there for thirty years. It was
a very strange situation. The idea was to make a large
group show in this tiny little space. In the beginning,
the room was empty, and little by little one had to sleep
with Annette Messager's stuffed animals. Fabrice
Hybert installed one of his first POFs [prototype of
a functional object] in the bathroom, a honeycomb-
shaped bath rug. There was also a group show in the
wardrobe: the visitor was invited to try on the clothes
of Erwin Wurm or Marie-Ange Guilleminot. Dominique
Gonzalez-Foerster had transformed the bathroom into
a yellow room. Andreas Slominski sent an instruction
everyday, as a sort of punishment for the curator, etc.
For two months, from 10 a.m. to 6 p.m., I was the landlord,
curator, exhibition guardian, and guide. I met many
people who came by, and that was the beginning of this
~~continual conversation~~ which remains one of the most
active aspects of my working method.

Do many exhibitions seem too conventional to you?

Yes, one often finds oneself in formats which are a bit
too fixed, without innovation in terms of spatial and
temporal dimensions, with a determined duration and
with typical or predictable artists. One must ceaselessly
question these conventions and ~~change the rules of the
game~~. The exhibitions which have changed things since
the end of the nineteenth century were all radical
experiments, which have modified the modes in which
art is being presented, like the Dada Fair in Berlin in
the 1920s or Marcel Duchamp's exhibition on Surrealism,
where there was a particular architecture—even a sort
of cave ... For me, it was a bit like the structure of Russian
dolls: one show a bit hidden within another. I always
ask myself how an exhibition can develop a life. It's not

simply about an opening or a closing, but a whole and autonomous life, a living organism which learns things, which evolves, and lasts longer than the closing date. Hence, I have always searched to invent other forms of trajectories.

Other examples?

In 1993, I installed the Robert Walser museum in a restaurant where Robert Walser himself often stopped in during his walks. The restaurant still exists, and the exhibition has really infiltrated itself there, like a supplement. It was a kind of literary museum, and I held onto this desire to cross not only sites and places, but also disciplines. I continued with a series of exhibitions in inhabitable places: Boltanski's books in the medieval library in St. Gallen in 1991, and Gerhard Richter in Nietzsche's house in Sils Maria. Later, I invited artists to the sewer museum in Zurich. I didn't want these shows to become routine, to turn into exoticism, or to become like a signature, and so I started to become interested in contemporary art museums, to co-organize group shows like "life/live" on the English scene with Laurence Bossé, and "Cities on the Move" on Asia with the Chinese curator Hou Hanru, etc.

Is an exhibition a critical activity?

Above all, I find that there is often a lack of experimentation, that one is always too afraid to fail. For example, "Laboratorium," in 1999 in Antwerp, was an exhibition where one had experiences, and ergo, errors. The exhibition is not a product to sell, but something that asks questions—there is a will to understand. This type of exhibition is truly lacking, and this idea of an experimental radicalism seems to me to be too rare. I think that big museums need and perhaps have a duty to turn the smallest entities into studios for pure research. We know that large museums have a project room dedicated to

young artists, but that becomes quickly ghettoized. Against this principle, at the Musée d'Art moderne de la Ville de Paris, with Suzanne Pagé and Béatrice Parent, we developed the "Migrateurs" series, which started in 1993. It's the idea of an exhibition with irregular dates, which permits an artist to intervene there, or if he/she wants, in the collections, but also in the cafeteria, in the toilets, or on the museum's exterior. For example, Douglas Gordon inserted a text in the collection and introduced a virus in the telephone system. It's a supple formula, migratory and unforeseeable in the interior of the museum. There have been more than twenty-five "interventions" ever since.

One imagines you always on a voyage, between airport waiting rooms ... How do you see yourself exactly?

I always have a city where I spend three to four days per week, and without that I can't concentrate. In the beginning, it was Frankfurt, then Vienna, Berlin, later on it was London, and now it is Paris. My central activities take place at the Musée d'Art moderne de la Ville de Paris. Outside of that research, conferences, and exhibitions take up the rest of my time. At the same time, e-mail permits me to constantly stay in contact. E-mail, as well as the Internet, though less so, have completely changed the way we work in the art field.

Don't you often have the impression that you're the incarnation of the "connected" man described by Luc Boltanski in the New Spirit of Capitalism: *adaptable, flexible, always connected?*

No, I think that resistance is very important. In fact, it happens between the voyage and the non-voyage, between slowness and acceleration. Because there's the intimacy of dialogue, and paradoxically that's something very slow. All week long, I have very slow conversations with artists and philosophers, and I sort of consider ~~this continual conversation~~ <u>the spine of my work</u>. There's an oscillation between the "connected" man and the unconnected man, and the

night train, for example, which I took for a long time while traveling through Europe, is a tremendous tool for reflection, a place and a moment of complete disconnectedness. Today, one must choose one's mode of communication, because one cannot respond to everything at the same time ... So, I decided to work only by e-mail, to be unreachable by telephone, and only really use my voice mail. But I know people who have decided not to use e-mail, not to correspond with anything other than fax. Each person negotiates the present moment, oscillating between being connected and disconnected.

Even so, I remember that you had really appreciated the theft of your mobile phone. Isn't that an acute connection?

Yes, it's true! I was walking down the street talking on the phone with the architect Cedric Price, who is one of my biggest heroes. He has designed the most visionary projects like the Fun Palace, "Cities on the Move," a university on wheels, etc. <u>We were speaking about the distortion of time, the fourth dimension, and what that would mean for architecture, when suddenly my mobile phone was stolen ... Some guy on a motorcycle took it and disappeared into the urban web. It was a strange moment: Cedric Price was on the other end of the line not understanding what had happened, suddenly having his voice swept away on a motorcycle</u>. It wasn't violent, but very "fluid-city." In the beginning, due to my own personal obsession in sparking spontaneous meetings, I would never give out my mobile phone number to anyone. Now I always leave it off, but I continue the work of a sort of border escort. I see myself often as a trigger, a catalyst.

So, don't you think about having applied contemporary ideologies about flexibility to your life?

Both linking and delinking are important. Both and instead of either instead of none.

Does travel also correspond to a new art-geography in the 1990s?

Yes, there are no longer only two or three capitals, but a multiplication of unique sites of activity. I understood that when I went to Glasgow in the beginning of the 1990s, to Transmission, an art space where artists organized exhibitions themselves; an incredible generation of artists emerged from there including Douglas Gordon, Christine Borland, and Jonathan Monk. The United States doesn't have that—we never speak about, for example, something fantastic coming out of Pittsburgh or Detroit. It's perhaps true in music but not in art. In Africa and Asia there are dozens of cities which produce passionate artists, but it is above all in Europe where we have the impression that the centers are displaced, and we jump a bit from here to there, in a completely unpredictable manner. At the moment, we speak a lot about Italy, but tomorrow it could be Belgrade, or another city, another country. Recently I did some research in Zagreb and in Istanbul where I found some really effervescent scenes. One has the impression that it's happening a bit everywhere at the same time, and that is what makes the European context very exciting.

What about the artistic landscape has really changed in the 1990s?

It's difficult to speak about it in a general manner, because today, in the era of the post-medium, all practices coexist: an artist can use video, installation, painting, drawing, the computer ... in return, one no longer sees the kinds of exhibitions where works come by transport, and one simply puts them on a wall. That was really happening in the 1980s, but by the end of the 1990s, it had become more and more rare. The notion of a work of art has changed, and also the way artists work. Often, works are produced in the context of this show or that show and are therefore ephemeral,

even if you find another version of the work elsewhere. There were also enormous amounts of collaborations throughout the 1990s between curators, and now the art dialogue is more and more related to other disciplines. For example, Pierre Huyghe is now working with the writer Douglas Coupland, Dominique Gonzalez-Foerster with Jay-Jay Johanson, and Melik Ohanian with the NASA scientist William Clancey ... These collaborations do not necessarily lead to a finished work, but are formed over time as a constellation of experiences.

One often blames you for a certain laissez-faire, that your exhibitions are a bit thrown together, barely sketched out ...

On the one hand, one must follow these projects very closely because without this dialogue an exhibition cannot succeed, and, on another hand, there is the will to let go, to open up into a more permissive space, to stay open, and to self-organize, all so that surprises can happen. <u>The ideal exhibition is the "cell city": a space composed of autonomous cells,</u> [similar to the t.a.z. of the Lyon Biennial. See Hakim Bey's *T.A.Z.: The Temporary Autonomous Zone, Ontological Anarchy, Poetic Terrorism,* Anti-copyright, 1985] which do not intrude upon each other, but make links between the works. I love this idea of creating platforms where something can happen, and <u>so the curator is not the controller, but the releaser.</u> <u>I am revolted by the curator who claims possession of "his" artists; to me this seems absurd</u>. There is a constant balance in finding continual work executed with certain artists and a permanent research on finding other creators, other disciplines, and generations. <u>It has to do with a sort of foot plank: throwing away bridges between works, artists, between the public and the art. My work is to liberate the path, to be a catalyst, and finally, to know how to disappear.</u>

Translated from the French by Sarah Crowner

If
It's
Tuesday

with Robert Fleck
1995

197

✻✻

The twenty-six-year-old Swiss curator Hans Ulrich Obrist lists Paris, London, and Vienna as his primary residences, but on any given day he can just as easily be found in Berlin, New York, or, for that matter, St. Gallen. Obrist leads a resolutely nomadic existence; he has traveled—visiting famous as well as lesser-known artists—since his student days, developing his peripatetic impulse, his notion of "permanently traveling," into a unique curatorial program. Commandeering sites from hotel rooms to sewage processing plants, Obrist has rediscovered (and reinvigorated) the ephemeral or "conceptual" exhibition while remaining acutely aware of the history of such endeavors and of his own place within it. Informed by a lively sense of intellectual play, exhibitions such as "Cloaca Maxima," in Zurich (concerning scatology, sewage, and desiccation), and "Take Me (I'm Yours),"[1] in London's Serpentine Gallery (about possession, use, and application), renegotiate the contexts within which art operates, while avoiding the doctrinaire pieties that inform so many similarly motivated efforts today.

I caught up with Obrist on the occasion of "Take Me (I'm Yours)" and talked with him about his wanderlust and his already impressive curatorial record.

✻✻

1. "Take Me (I'm Yours)" at the Serpentine Gallery, London, closed on May 1, 1995. The exhibited artists were Christian Boltanski, Hans-Peter Feldmann, Jeff Geys, Gilbert & George, Douglas Gordon, Carsten Höller, Christine Hill, Fabrice Hybert, Wolfgang Tillmans, and Franz West.

Robert Fleck — *You just organized an exhibition at London's Serpentine Gallery in which one could and indeed should touch the works.*

Hans Ulrich Obrist — The show, "Take Me (I'm Yours)," revolved around artworks that reconsider the relationship between the work and its observer. Visitors could touch, use, test, buy, or take away the things in the exhibition, which all functioned both as utilitarian objects and as works of art. Here the public was allowed to do all the things that are usually strictly forbidden in an art gallery or museum. The show wasn't only about observing; it was about the other senses and multiple notions of dispersal and dissemination.

Since September of 1994, you've been organizing two "exhibitions" in the Austrian daily paper Der Standard *for the museum in progress, a private organization in Vienna. The first, "Vital Use," is an open forum for artists, and so far it has included works by Fabrice Hybert, Hans-Peter Feldmann, and Wolfgang Tillmans. In "Exhibition of the Year," initiated by Stella Rollig, the New York artist Nancy Spero presented inserts in six separate issues of the paper, culled from her research of experiences strongly influenced by the Holocaust. Is a newspaper an appropriate medium for exhibitions?*

The thing about newspapers is that image and text never stand alone; everything is made up of relationships between written and visual messages. A newspaper is a network; it exists in an unstable equilibrium—between ad, image, text, and editorial. "Vital Use" is an exhibition in this interspace. The artists go into it to change it—to change the rules.

In Paris you have organized a number of "alternative" exhibitions that have taken place in studios or private apartments.

In the summer of 1993, I turned my hotel room into an exhibition space. I wanted to make an intimate space

a public one for a specific period of time. <u>During the first few weeks of the show, the porter would announce visitors over the hotel telephone like this: You have a "client" here</u>. By the show's last day, *Libération* and *Figaro* had written about it, and there were people lined up in the street to get in. I also organize six small exhibitions per year at the Musée d'Art moderne de la Ville de Paris. They are mounted at various sites around the museum, not necessarily designated for exhibition —Rirkrit Tiravanija, for instance, installed a coffee and tea table at the museum entrance—that serve as a kind of mobile platform.

Last October, in the Kunsthalle Ritter in Klagenfurt, Austria, twelve artists composed "Instructions for Use," how-to manuals for an exhibition you organized called "do it" (as in do-it-yourself).

"do it" started from a conversation I had with Bertrand Lavier and Christian Boltanski about the idea of an exhibition that would consist exclusively of instructions. <u>In the 1970s, Lavier had presented directions for the anonymous viewers to carry out. They became the work's performers, and in this sense were permitted a measure of aesthetic as well as political power. Boltanski has always been interested in the idea of the musical score: the artist writes a score and can perform it him —or herself, or it can be performed by someone else. In the 1960s, Alison Knowles called her instructions "event scores," and in 1919 Duchamp sent instructions for the realization of *Readymade Malheureux* [Unhappy readymade] as a present to his sister. In the case of Guy Debord, instructions are used as a parody—a detournement of function</u>.

For "do it," everyone who followed the instructions —materialized the instructions, as it were—made a facsimile; and there was no original, only facsimiles, copies. The idea is not the same as when the artist's assistants travel with a show, realizing his concept as

meticulously as possible. Rather, the idea is a much more conscious, productive misunderstanding. It is an old Dada-Duchamp-Fluxus idea, which one can trace back to the Marquis de Sade: everything is in a permanent state of transformation. Everything is changing.

You're not yet twenty-seven, and you began showing up in galleries and studios ten or twelve years ago. You're certainly one of the youngest curators around.

From the beginning my interest has been in research. My notion of an exhibition entails permanent research and, therefore, a permanent journey. A constant, intensive <u>nomadism provides the structure for everything I do</u>. The basis of my shows is the idea of the rhizome or root stock, a nomadic form quite unlike the "structures" found in the traditionally large, centralized exhibitions, which no longer possess an immanent, critical power. For me, constant research and dialogue with artists is primary, and from time to time this permanent rhizomatic process necessarily precipitates down into an exhibition. The books I publish are just as important to me. They include artists' books (Gilbert & George, Annette Messager, Gabriel Orozco, among others) as well as editions of the collected writings of Louise Bourgeois, Leon Golub, and Gerhard Richter.[2] Right now I'm working with Guy Tortosa on *Unbuilt Roads,* a book and an exhibition about artists' projects since the 1970s that never materialized.

It would appear that the art of the 1990s is coursing with many contradictory, incompatible currents.

2. Gerhard Richter, *Text: Schriften und Interviews,* ed. Hans Ulrich Obrist (Frankfurt am Main and Leipzig: Insel Verlag, 1993; Cambridge, MA: MIT Press, 1995); *Leon Golub Do Paintings Bite? Selected Texts, 1948–1996,* ed. Hans Ulrich Obrist (Stuttgart: Cantz, 2002). *Louise Bourgeois, Destruction of the Father, Reconstruction of the Father: Writings and Interviews 1923–1997,* ed. Marie-Laure Bernadac and Hans Ulrich Obrist (London: Violette Editions, 1998).

But it isn't an issue of trying to create a huge movement. It is no longer a matter of launching a group of artists and sending them off into the world as a coherent package. I mistrust this coherence, these closed systems. History is a wide-open field. What is important is to create connections among various positions and disciplines —without letting this impulse degenerate into inter-disciplinary dogma. In a certain sense, the curator is a catalyst and must be able to disappear at a certain point. <u>One can never entirely plan "in-betweenness."</u> They always develop differently than one would expect. The meeting I organized at the Jülich research center for <u>"Art and Brain" had all the constituents of a colloquium except the colloquium. There were coffee breaks, a bus trip, meals, tours of the facilities, but no colloquium.</u> The artists made their contacts, and they can go back there to produce works and to work with the scientists. Now things are developing there without any need for more centralized organization. The Jülich project is one example. Next is a project at the university in Lüneburg. These research projects lead to collaborative projects: artists and scientists forming hybrid research groups.

Your 1994 exhibit "<u>Cloaca Maxima</u>" received enormous attention in Europe, especially considering its low budget, and the fact that <u>it was held in a museum that wasn't a museum</u>.

"Cloaca Maxima" was a thematic exhibition in Zurich that took as its topics "art, sewage, scatology, and the toilet." There was an ecological dimension, considering water as a resource in a political context or manner, but there was also an attempt to bring art into a field where it had never previously been taken or had turned up. In this case that field was Zurich's sewage treatment plant, which was turned into a sewage museum.

It was the first art exhibition in a museum where officials from the city administration demonstrated the quality of their sewage treatment.

The idea was to mount a low-budget art exhibition in that setting. (The whole thing cost about 30,000 DM [ca. $21,000]). The administration simply trusted me to show art. The exhibition showed the artists' proposals next to what already existed at the site: a trusty chamber pot; a nineteenth-century ceramic toilet; and a modern flush toilet, where the toilet paper was automatically replaced by pushing a button—à la James Bond from the 1970s, etc. The existing sewage museum wasn't renovated, and most of the artists designed or selected works especially for the space. <u>Incidentally, the departure point was a video by Fischli/Weiss on sewage TV.</u>

The exhibition was perceived as an art show, but it entered other fields by infiltration. I want my exhibitions to infiltrate and infect other fields, other disciplines. I want to send a "virus" into the world. [Said elsewhere about "Migrateurs," i.e., to infiltrate a large museum like a virus.] Because of its theme [scatology] and its location [a sewage museum], "Cloaca Maxima" was discussed in contexts in which contemporary art had never been discussed before.

So the exhibition is a vehicle to leave the context of art?

A vehicle to take art into other fields, where it can be relevant. It isn't that one continually makes everything into art but rather, that at a given point in time one simply says, these are statements by artists, and they are relevant. Another function of an exhibition curator should be to create situations in which artists' proposals catapult into the public sphere. When art only resides in a museum, the usual stream of visitors flows by, and it can lack this effect of disturbance. With regard to the question of museum spaces versus those outside the institution, the question is not "either/or" but "both/and," without hierarchy. ~~Marcel Broodthaers always said the museum is one truth surrounded by many others equally worth exploring~~.

Translated from the German by Franz Peter Hugdahl

Afterword by Yona Friedman

A curator is the key person for information transmission through objects.

Indeed, a work of art is an object vehicle for a message. That message is not explicitly formulated; it has to be deciphered by the spectator. A rebus.

It is the curator who "makes a text" out of the collection of distinct messages formed by each work of art displayed in an exhibition.

Being an architect, I will try to take from conclusions triggered by the above definition, concerning the role of a building as a shape for the exhibition, for the "work of art" specific to the curator.

In most cases, in my opinion, the building of a museum is superfluous. The main part of the exhibition is expressed by objects and the "text" the curator writes —the building enclosing the exhibition is generally only an annoyance. (The same goes for the theater: a drama need not to be performed within a building.)

I myself had reasons to "build" several such building-less museums—an agglomeration of showcases, a labyrinth of screens will do the job, leaving freedom for the curator to shape his world. (Witness the Street Museum in Como, Graffiti Museum in Paris, and the Museum of Afghan Civilization.)

An extreme case of this idea was my project for what is now the Pompidou Center in Paris: a building, surely, which can change its shape (inside and outside) for each new exhibition.

I would like to conclude these thoughts with a project of mine from the year 2000. It was in response to a challenge: I had been asked to propose a museum of the twenty-first century "to be built in the year 2000."

I suggested that such a museum might be materialized by simply building a small neighborhood (in Paris). This neighborhood would continuously change during the century to come: not only the private homes and shops, but also the public spaces, facilities, public artworks, etc.

Once every five years during that century, a committee would visit the neighborhood and "freeze" certain features: a home, a mailbox, a streetlight, an advertisement. The "frozen" features would then constitute the museum.

Thus, the museum "builds itself." The main role is that of the effective inhabitants, and that of the committee, and the curator.

I would like to finish this afterword to Hans Ulrich's book with a word about his personal discovery, which reaches beyond the building-less museum, the museum of "object-messages": Hans Ulrich curates a museum made with words, with texts, with interviews. The artists he presents are not represented through artworks but through their ideas; more exactly, through "traces" of their ideas interpreted by the interviewer.

A monument of communication.

I encourage you to stroll again and again within this labyrinth at your pleasure. And perhaps, you have already made your own marginal remarks. Thus, it has already become a book which is "making itself."

Paris, July 2009

Colophon

Everything You Always Wanted to Know About Curating
By Hans Ulrich Obrist

Publisher: Sternberg Press
Editor: April Elizabeth Lamm
Editorial Work: Tatjana Günthner
Proofreading: Melinda Braathen, Kari Rittenbach,
Leah Whitman-Salkin

Graphic Design: Z.A.K.
Typeface: Larish Neue by Radim Peško
Printing: GGP

© 2011 Hans Ulrich Obrist, April Elizabeth Lamm,
Sternberg Press, the editors
All rights reserved, including the right of reproduction
in whole or in part in any form.

ISBN 978-1-933128-25-2

Sternberg Press
Caroline Schneider
Karl-Marx-Allee 78, D-10243 Berlin
1182 Broadway 1602, New York, NY 10001
www.sternberg-press.com

A Note on the Type
The interfinity mark (?) used in
this book can be described as
an interrogative punctuation
mark formed by superimposing
a vertical infinity mark (∞)
with a question mark (?). The
interfinity mark differs from the
short-lived percontation point,
invented in the late sixteenth
century to indicate rhetorical
questions, in that it denotes
ever-lasting and ever-occurring
questions. An interfinity ques-
tion is a question that has both
an infinite number of answers
and no answer at all.

But Were Afraid to Ask